IMAGES
of America

PATERSON

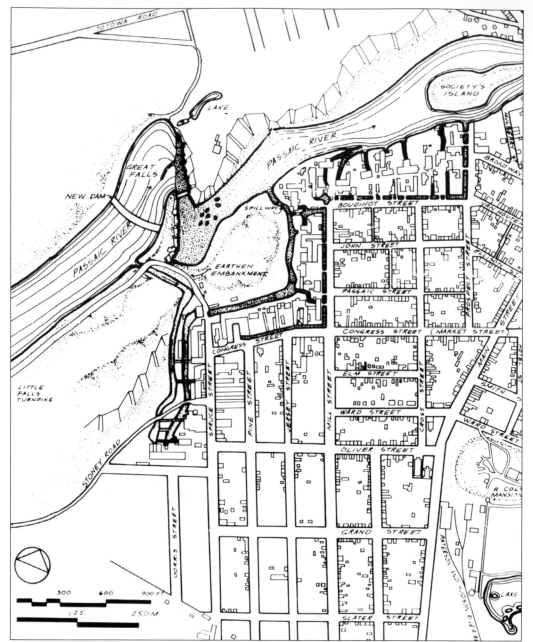

In its infancy, the Society for Establishing Useful Manufactures (SUM) hired Pierre-Charles L'Enfant to design a system to divert water from the Passaic River to run the mills. However, the plan by L'Enfant, designer of the Washington, D.C. streetscape, was considered too ambitious, and he was replaced by Peter Colt. By 1794, water was flowing to the mills, but Colt's reservoir-based system proved problematic. A system similar to L'Enfant's was embraced in the second half of the 1800s.

IMAGES
of America

PATERSON

Philip M. Read

ARCADIA
PUBLISHING

Published by Arcadia Publishing
Charleston SC, Chicago IL, Portsmouth NH, San Francisco CA

Printed in the United States of America

Library of Congress Catalog Card Number: 2003106110

For all general information contact Arcadia Publishing at:
Telephone 843-853-2070
Fax 843-853-0044
E-mail sales@arcadiapublishing.com
For customer service and orders:
Toll-Free 1-888-313-2665

Visit us on the Internet at www.arcadiapublishing.com

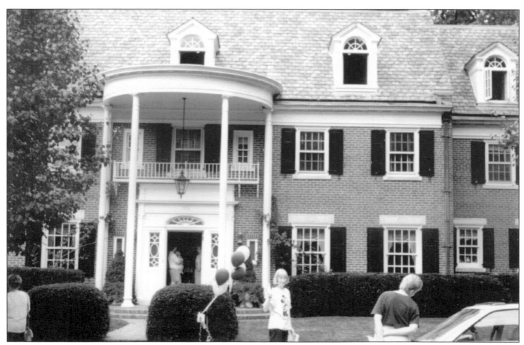

Paterson's Eastside section, home to the city's elite, is a busy place in late summer or early autumn as the Eastside Neighborhood Association conducts its annual fund-raising house tour, giving visitors an inside look at the spacious estates, such as this one on Derrom Avenue.

CONTENTS

ACKNOWLEDGMENTS

There are certain people who made this pictorial work possible. As such, words of thanks go to Jack DeStefano, director of the Paterson Museum, for offering up the museum's archives to further the appreciation of Paterson's history; Joe Costa, the museum's photo archivist, for his valuable assistance; Richard Walter, whose commitment to Paterson's history is perhaps most evident in his labor of love, www.patersonhistory.com; Michael Lemme of the Eastside Neighborhood Association for his assistance in helping to reveal that hidden gem of a neighborhood; Danforth Library director Cynthia Czesak, who is surrounded by the artwork of the masters; and to the staff of the library's local history room, whose collection of research and clippings made this work much easier than it might otherwise have been.

INTRODUCTION

There are exceptionally few New Jersey cities that exude as much history as Paterson. Here, the engine that powered Charles Lindbergh's *Spirit of St. Louis* on the first-ever transatlantic solo flight was created. Here, Henry Bacon, architect of the Lincoln Memorial, laid out his vision in the name of the Danforth Library. Here, John Holland, the Irish-born parochial school teacher, perfected the modern submarine, not in the name of war but in peace. Alexander Hamilton walked the paths near the Great Falls, dreaming of an American trophy for the Industrial Revolution. Pierre-Charles L'Enfant, creator of the Washington, D.C. streetscape, was hired to create Paterson's industry-crucial raceways and was ultimately dismissed for a vision deemed too grandiose.

Here, too, was a place comedian Lou Costello could not forget.

"I never should have left Paterson," he quipped in the 1951 film *Abbott and Costello Meet the Invisible Man.* Perhaps that helped explain why he kept coming back for premieres at the Fabian Theater, a movie palace built by none other than Paterson's own movie-house mogul, Jacob Fabian, who just happened to be a congregant at the Temple Emanuel in the luxurious Eastside section.

This place just 12 miles from Manhattan was where Garret "Gus" Hobart came from and where President McKinley, visiting the vice president's home after Hobart's death, said simply, "No one outside of this home feels this loss more deeply than I do."

This city of Paterson was a venerable *Who's Who.* It was home to Larry Doby, the Cleveland Indians ballplayer who in 1947 broke the color barrier in the American League. The list of Paterson-born ballplayers is long. It includes Joe Cunningham of the 1960s-era Chicago White Sox and John Briggs of the Philadelphia Phillies. Perhaps Paterson's favorite athletic was Eleanor Egg, the 1920s track star who caught enough attention to become the subject of a bronze by Gaetano Federici, Paterson's renowned sculptor.

Paterson was also the home of Nobel Peace Prize winner Nicholas Murray Butler, president of Columbia University, and Bernie Wayne, who penned "There She Is, Miss America."

It was the launching point for not just shuttle astronaut Kathryn Sullivan but also many careers in public service, including those of Sen. Frank Lautenberg, Rep. Bill Pascrell Jr., Robert Torricelli, and William Simon (the deputy Treasury secretary in the Nixon administration). It was big enough to catch the eye of those with presidential ambitions, a sure stop for everyone from Eisenhower to Willkie.

Paterson is a place with its share of folklore. "The Ghosts" of Eastside High football fame did not get that moniker by accident. The school sits on a one-time cemetery, the bodies long since moved to other resting places. It is a place that could attract thousands of fans to Hinchliffe Stadium for the annual Eastside-Kennedy rivalry, or for bouts of Golden Gloves boxing, or even midget car racing.

And there was pain, the sense of loss from fire, flood, labor strife, and poverty—the kind of ills that still dog America's historical basins of culture to this day.

This is Paterson, New Jersey, and in this day of bumper stickers saying, "I Rediscovered Downtown Paterson," the city holds even a greater promise to those seeking to rediscover its history and financial potential.

One

ALL AROUND THE TOWN

There are no real bad boys, just good boys "doing the wrong thing. . . ."
Give them a place where they can enjoy good, clean, wholesome fellowship
and recreation, and you will be heading off juvenile delinquency.

—Lou Costello, alluding to his famous saying "I'm a B-a-a-d Boy" (from a boyhood experience at Paterson School No. 15) while at the dedication of a recreational center for disadvantaged children in Los Angeles.

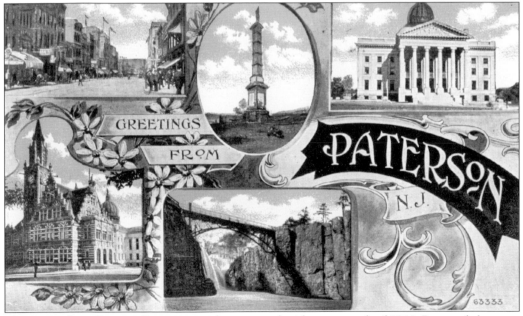

"Greetings from Paterson" announces this postcard with a postmark of 1918. Postcards became widely used after the 1898 passage of the Private Mailing Card Act, freeing publishers from what they considered unfair competition from government-issued postcards. A golden age of postcard publishing and collecting followed, and in the fiscal year 1907–1908 alone, more than 677 million postcards were mailed in the United States.

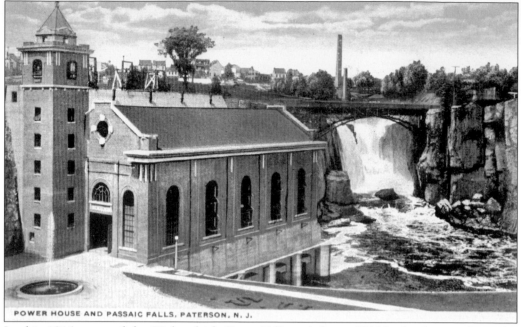

POWER HOUSE AND PASSAIC FALLS. PATERSON. N. J.

In this 1916 scene of the 77-foot-high Great Falls and the *c.* 1914 hydroelectric plant, the mist apparently was not enough to cool a visitor, who wrote in August, "It is very warm here. I hardly know what to do with myself." In times of cleaner water, however, the base of the falls was perfect for this swimming school. (Courtesy of the Richard Walter collection.)

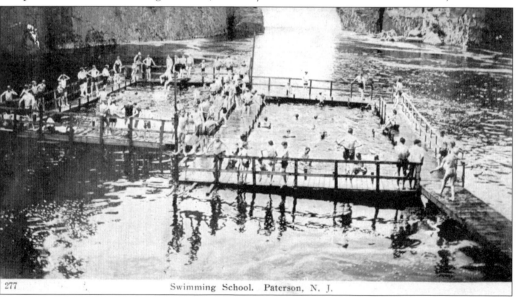

277 Swimming School. Paterson, N. J.

PASSAIC RIVER AT LINCOLN BRIDGE, BY MOONLIGHT, PATERSON, N.J.

It was easy to rent a canoe or boat to venture out on the Passaic River in the early 1900s. The Passaic Valley Canoe Club, with a membership of 125 and a clubhouse that could accommodate 82 craft, had its first water carnival on June 27, 1906, noted E.A. Smyk, the Passaic County historian in a "Tales of Our Heritage" column. "Fifty canoes were decorated in all manner of beautiful designs," he quotes from a brochure from the day, "and myriads of Japanese lanterns made the river above the Falls appear like a fairyland. The shores were filled by 10,000 people. Fireworks were displayed by property owners from the Falls to High Bridge."

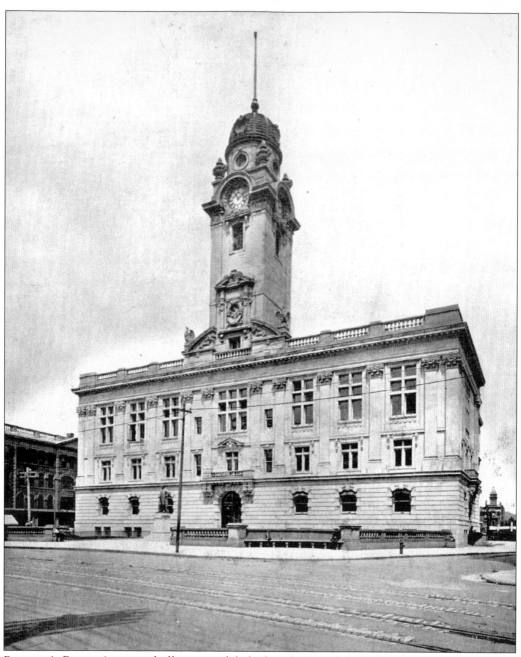

Paterson's Beaux-Arts city hall was modeled after the Hotel de Ville, the city hall of Lyon, France, then known as the Silk City of the Old World. Featuring a majestic clock decorated with foliate wreaths and shields, the city hall rose in 1902. It also features a recently refurbished stained-glass window of Paterson's first mayor, John Jackson Brown, sporting a tuxedo and bushy brown beard. Another window shows John Ryle, the father of the American silk industry. The Brown window, dating from 1896, was saved from the city hall that burned down in the Great Fire of 1902. Only the hall's tower and its four-faced, 4,000-pound clock, with a 500-pound pendulum, survived the flames. Today, the building is listed on the National Register of Historic Places.

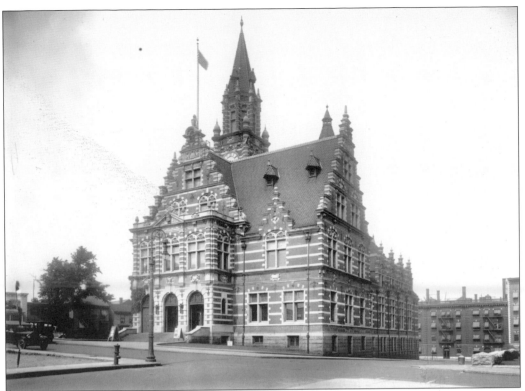

Paterson's post office has been compared to the lavish Vleeschal, or Butcher's Hall, in Holland, itself a work of architect Lieven de Key, who was born in 1560. When new in 1899, the post office was noted for its red brick and roof, its steep gables, and clock tower, as it is today, having gone through various restorations. (Courtesy of the Paterson Museum.)

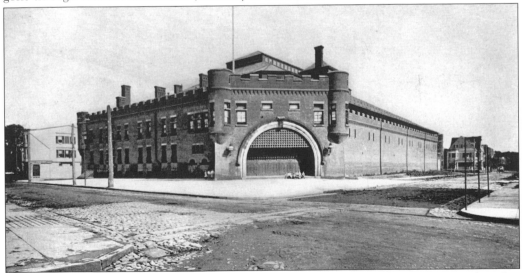

It was an American institution, and particularly a Paterson one. Civil War veterans gathered at the laying of the cornerstone for the Armory on Memorial Day 1894. In the ensuing decades, it would play host to presidential aspirants, to such boxing legends as Joe Louis and Gene Tunney, even to the famous attorney Clarence Darrow. The last troops moved out in 1983.

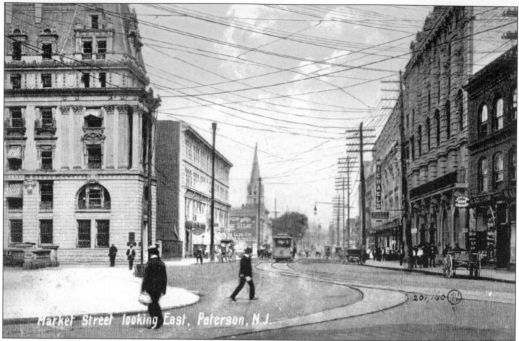

Market Street in the pre- and post-automobile age has a vastly different feel. Still, the appeal of driving was too great, so much so that in 1929 a Miss Chevrolet undertook the ultimate endurance test, a 100-hour drive handcuffed to the steering wheel to prove the driving meddle of "the weaker sex." The stunt was touted in ads by Harry M. Smith (the Chevrolet Man), whose outlets included one at Market and Twenty-fourth Streets. There was a contest for those who came closest to guessing her mileage finish and a chance to chat with the lady at the dealer's showroom once the ordeal was over.

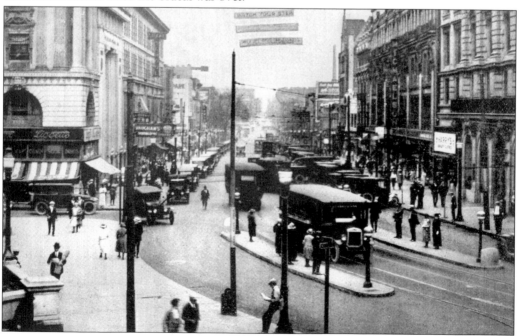

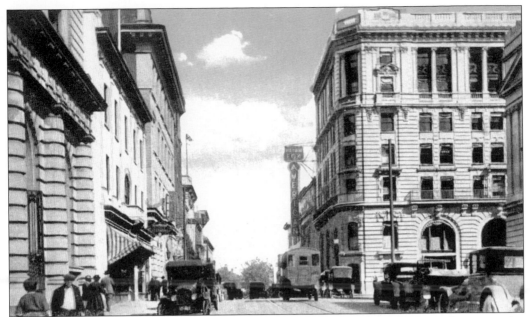

Ellison Street had its share of motor vehicles c. the 1920s. At 192 Paterson Street, at the southwest corner of Ellison, in 1927 could be found the W. Sarbone Company, whose slogan was "Everything for the Automobile." Among the sale items were "Famous Fandanco Auto Slip Covers." A full set of 10, with fasteners, would run the buyer $10.95. "No longer, now, need one have soiled, worn, germ-laden upholstery," read the shop's advertisements.

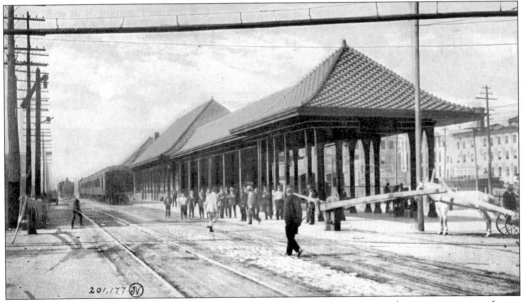

The Erie Railroad acquired the Paterson line in 1852, in the process obtaining a more direct connection with New York City. Here, a horse and buggy waits to cross the tracks, later raised on platforms to prevent such delays. By 1929, the familiar faces around the Paterson station included H.G. Cooke, traveling freight agent; J.H. Graf, ticket agent; and A.R. Walton, division freight agent. (Courtesy of the Richard Walter collection.)

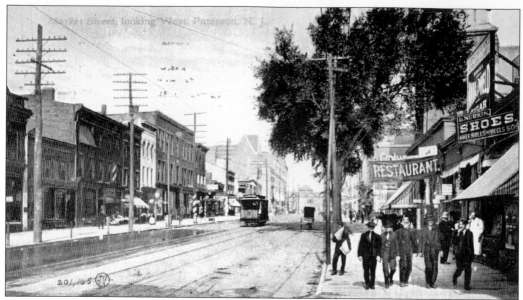

A trolley dominates the roadway along Market Street in this 1912 view as a newsboy tries to get the attention of passersby. In 1918, headlines announced a special effort to keep returning servicemen in line. One headline read, "Prevent Sale of Liquor to Service Men." Secretary of War Baker had issued a telegram. "Now that war is over and the men will soon be released from service," the article said, "it is the intention of the government to return them to their homes in the best of health, and that in order to be so they must be held in check and saloonkeepers watched." Paterson's police chief ordered the arrest of any barkeepers caught serving drinks to uniformed men.

Paterson's Broadway was not exactly the Great White Way, but you could get into pictures there. "It pays to be a reader of the *News*," touted a late-1920s ad for the newspaper. "Free! Your Kiddie's Photo, 5 x 7 inches, in a Beautiful Album." All it took was a coupon with your name and address and an appearance at Homecraft Photo Studios at 111 Broadway.

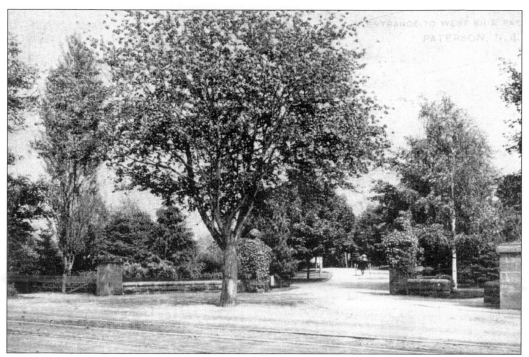

Once inside the entrance to Westside Park (above), there were special attractions. Writing in August 1906 to a friend in New York City, Lydia shared a little secret about the willows and the bridge (below) in Westside Park: "This is where the lovers spoon at night. Isn't it a romantic spot? I have only been there in daytime. Come over soon."

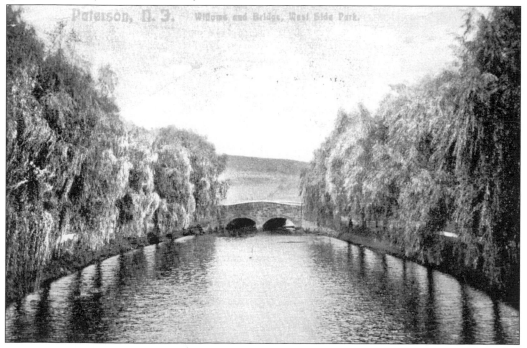

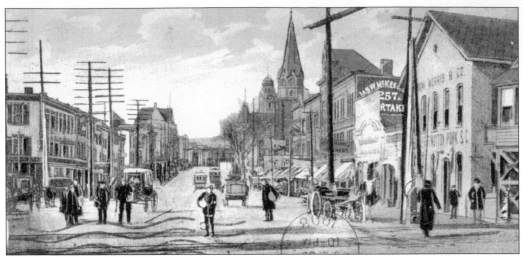

Market Street from the Erie Railroad is a bustle of activity in this c. 1908 scene. It would be 20 years before the automobile ruled the roadways, with downtown dealerships enticing buyers. Pierce-Arrow, which had a showroom at 157–161 Park Avenue, would hawk its $2,495 Runabout this way: "What a car for self-reliant women! . . . Bridge parties and teas, shopping trips, football games, delightful runs into the country." The Runabout model got 14 to 17 miles per gallon.

The Central Market along Railroad Avenue at Clifton's border is the farmers' market. Then, as now, it features an open-air bounty of fruits, nuts, and seafood.

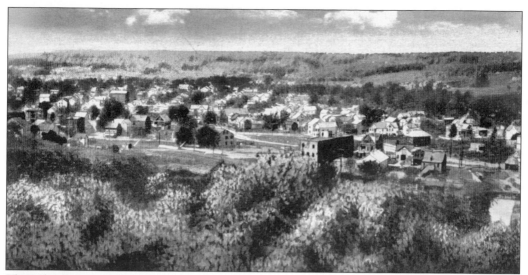

These bird's-eye views chart Paterson's development. Such vantage points were popular for publishers of postcards during the early 20th century.

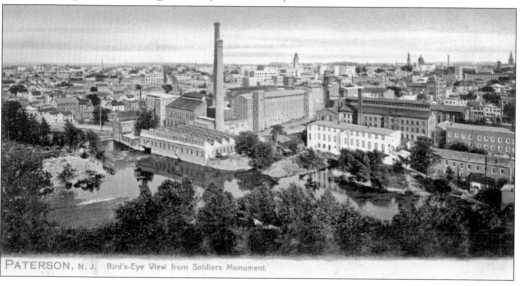

PATERSON, N. J. Bird's-Eye View from Soldiers Monument.

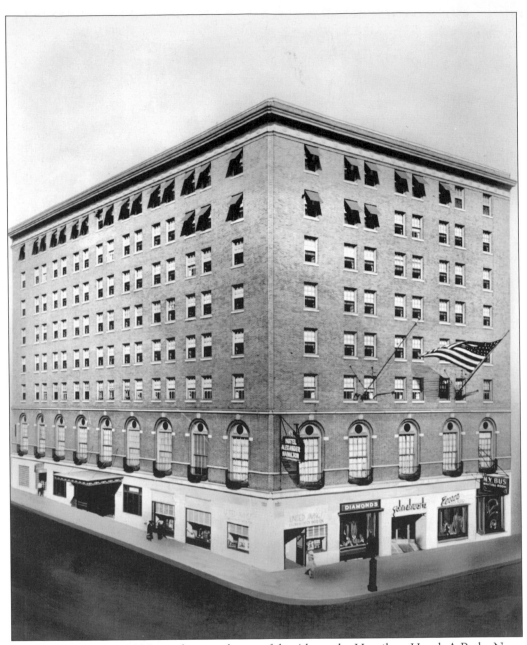

The big news in June 1925 was the completion of the Alexander Hamilton Hotel. A Pathe News cameraman filmed the opening ceremonies of the new eight-story hotel, at Church and Market Streets. Soon after, the film was shown as a trailer in theaters in Paterson and elsewhere. There was a parade with the police band playing the national anthem. Charles Carrigan, directing manager of the Alexander Hamilton Hotel as well as the Robert Treat Hotel in Newark, even laid a wreath at the foot of Hamilton's statue at the city hall plaza. Then he saluted the image of the statesman. (Courtesy of the Paterson Museum.)

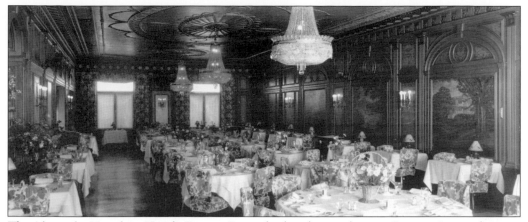

The Alexander Hamilton Hotel's Pioneer Room displayed a mural noting Paterson's contributions to industry and westward expansion and was one of many in the dining halls, shown c. the 1940s. During the hotel's opening week in 1925, no detail was overlooked to keep to the hotel's namesake theme—Hamilton. Each dining room had a seven-piece band playing tunes from the time of Washington's inauguration. Sheet music of the time was reproduced and handed to the guests. "Old-fashioned dances, such as the Virginia Reel, Nantucket . . . together with old songs featured the event," wrote a reporter for the *Paterson Evening News*. Charles Carrigan, the directing manager, spoke of the famous connection: "Major L'Enfant, who laid out the magnificent national capital, Washington, was chosen to lay out the new industrial city. The Society for Establishing Useful Manufactures, known as the SUM, was created with a capital of $1 million, which was a huge sum for those days. The state of New Jersey gave the company a charter for this site, covering six square miles. Paterson was thus started by Alexander Hamilton with a company doing business in the manufacture of cotton." There was more controversial news in that day's newspaper. The city's purchasing agent, A.W. Peardon, who had a reputation for being a "butt-in and very much over-officious" according to the news report, was in trouble again. Peardon had refused to okay the purchase of a time clock for the health center. "He [Peardon] did not think that city employees ought to be compelled to punch up their time," read the news report. (Courtesy of the Paterson Museum.)

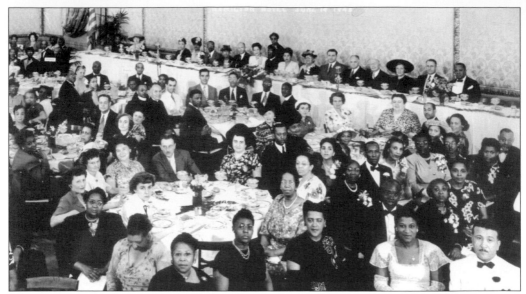

The Alexander Hamilton Hotel was the premier location for testimonial dinners and the like, as it was in June 1948. Then, the AME Zion Church conducted one for Rev. James C. Taylor, who served the congregation from 1939–1948. It was under Reverend Taylor that the mortgage was paid and the name of the Godwin Street AME Zion Church was changed to the First AME Zion Church. The congregation of this church traced its roots to 1834. (Courtesy of the Paterson Museum.)

The Hamilton Trust Company was operating out the First National Bank at the time of the Great Fire, which claimed First National. Yet, the Hamilton Trust Company had already secured the property at Market and Washington Streets for this work of architect H.T. Stephens. In a January 1906 article in *Architects and Builders* magazine, the writer notes the purpose was to impress: "An office building with the lower stories devoted to banking rooms would have been a more profitable investment but would have lacked the monumental appearance of this building." Fast-forward to September 1929, and the Hamilton Trust Company ran an ad asking, "What Financial Progress Will You Make Before Labor Day, 1930? You alone can answer the question!" Well, not entirely. The ad ran beside a news story speaking of a stock market "reaching for the sky." In a few short weeks, Wall Street would sink to the depths, with the crash of 1929 marking the start of the long Great Depression.

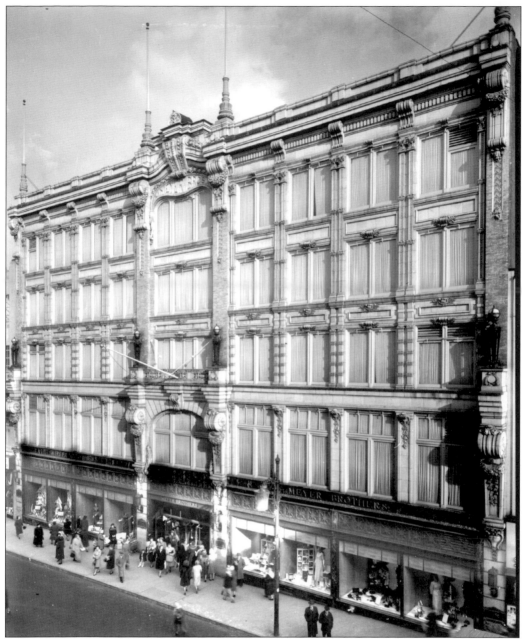

The Meyer Brothers store had its humble beginnings when Bert Meyer, a street vendor, opened the Boston Store in 1878, eventually changing its name to Meyer Brothers, which stood on Main Street for more than a century before falling in flames in 1991. Its revolving doors were made of solid brass, its floors of marble. Saleswomen were said to dress entirely in black, forbidden to wear jewelry that might distract attention from the merchandise. For a time, Bert Meyer lived in a suite at the Alexander Hamilton Hotel. Today, an open-air mall occupies the spot, but a two-story strip of the ornate stonework remains (far right), a reminder of its place in Paterson's retail history. (Courtesy of the Paterson Museum.)

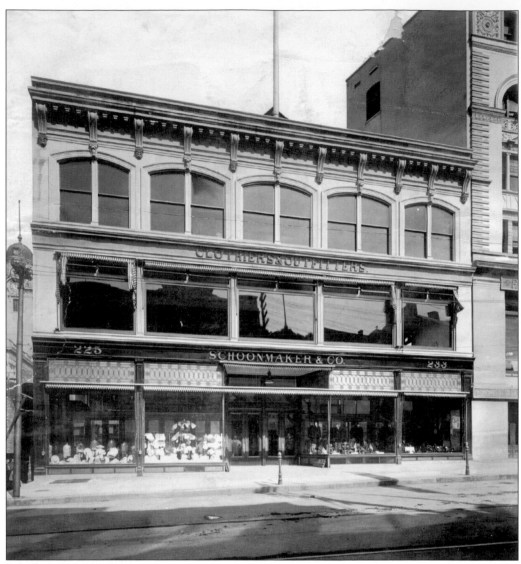

Schoonmaker & Company was not just a fine clothier of its day but, in this case, the architectural handiwork of noted Paterson resident Fred Wesley Wentworth, who had a hand in much of the rebuilding after the Great Fire of 1902. Among Wentworth's many creations were Passaic General Hospital, Paterson's Barnert Memorial Hospital, and Paterson School No. 10. In later years, he turned his attention to entertainment venues, designing the Regent and Capital in Paterson and the Branford in Newark, among others. As for Schoonmaker, the store stood at 225–233 Main Street. In 1918, it advised wartime shoppers to "Shop Before Six O'clock. 'Save coal,' says the fuel administrator, 'and shopping early every day of the week helps to save coal.' " (Courtesy of the Paterson Museum.)

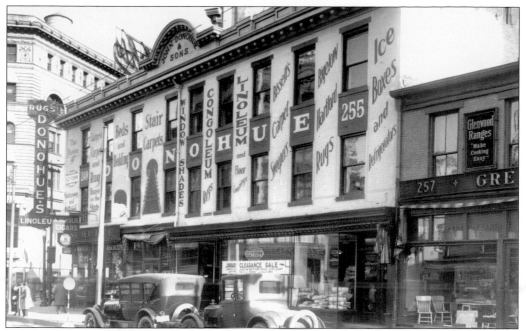

Donahue's—the flooring company—was not shy about touting one of its prized carpeting jobs. "All Those Lovely Carpets Came From Donahue's" was the quote topping a newspaper ad in a special 1925 edition devoted to the opening of the Alexander Hamilton Hotel. "Of Course, We're Proud Of The Fact That The Carpet On The Floors of Every Room in The Alexander Hamilton Hotel . . . Were Purchased From Us." On the same page of that Paterson News special section, Gurney Boilers and Ranges, whose storefront was at 181–185 Ellison Street, took out an advertisement hinting at its sense of humor: "Will Make It Hot For You." (Courtesy of the Paterson Museum.)

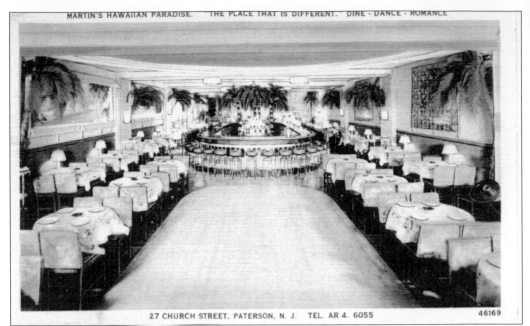

27 CHURCH STREET. PATERSON, N. J. TEL. AR 4. 6055 46169

Martin's Hawaiian Paradise, run by manager M. Spinella at 27 Church Street *c.* 1940, was touted as a place offering "a glimpse of Hawaii in all its beauty and grandeur." Two orchestras and twice-nightly floorshows did not hurt. The sender of the postcard seen here had this to say about his adventures: "Hi kid. Here is where Bob and I wound up after we made two swell pick-ups. Scotty." (Courtesy of the Richard Walter collection.)

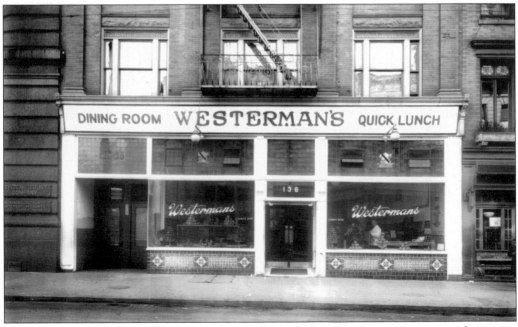

Westerman's was always open next to the old Citizens Trust Company. As promised, it was a place for a "quick lunch." (Courtesy of the Paterson Museum.)

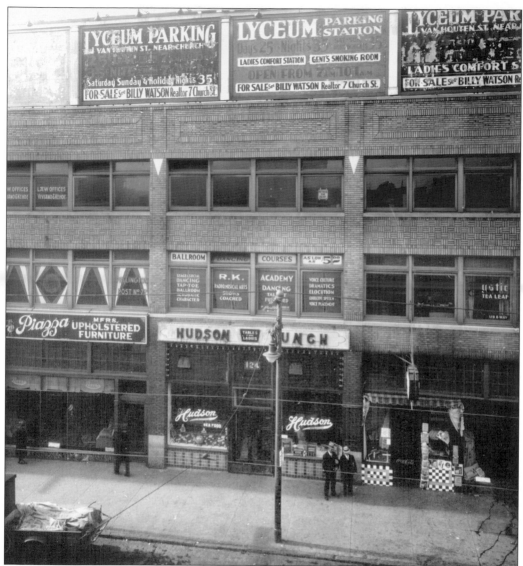

Hudson Lunch had seafood and, as the sign says, "Tables For Ladies" in 1934. Upstairs, there was a chance to work off the calories, with ballroom and tap-dancing lessons. (Courtesy of the Paterson Museum.)

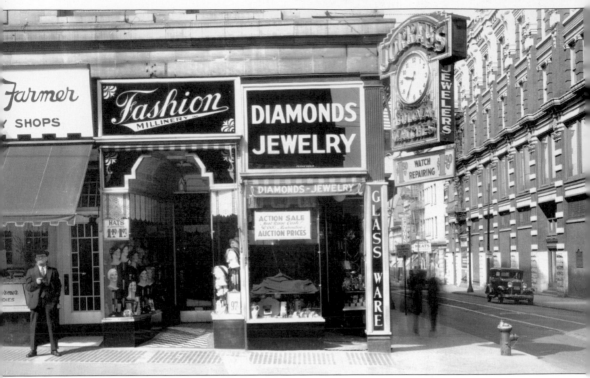

Main and Ellison Streets were a shopping mecca in 1932, with a Fanny Farmer and Jorray's, a seller of Bulova watches. The Fanny Farmer chain started in 1919, when candy maker Frank O'Connor named his operation after Fannie Merrit Farmer, who suffered from childhood paralysis but went on to become the "mother of measurements." She introduced precise measurements—such as a level teaspoon—and in 1896 produced the bestselling *Boston Cooking School Cookbook,* which has sold more than three million copies and is now known as the *Fannie Farmer Cookbook.* Four years after her death, O'Connor opened the first Fannie Farmer in Rochester, New York, with its signature blinking lighthouse in the window. Before long, there were 350 stores in 22 states. Fanny Farmer candy packaging had holiday themes that today have become collectibles. The chain was purchased in 1992 by the Archibald Candy Corporation. As for Bulova, just six years before this picture was taken, the watchmaker made history with the nation's first-ever radio commercial: "At the tone, it's 8 p.m., B-U-L-O-V-A. Bulova watch time." (Courtesy of the Paterson Museum.)

You could shop for furniture or catch a movie next door at the U.S. Theater. In this case, the film is Cecil B. DeMille's 1931 feature film *The Squaw Man*, a tale of a British captain who heads for the American West after taking the blame for an embezzling cousin to protect the cousin's wife, whom he secretly loves. (Courtesy of the Paterson Museum.)

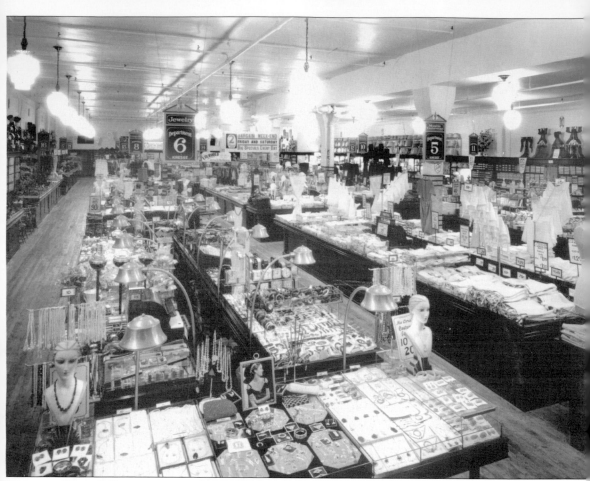

Kresge's Paterson store—known in the chain as store No. 1221—was part of a retailing empire whose humble beginnings were in Detroit, where Sebastian Spering Kresge opened a modest five-and-dime more than a century ago. By the mid-1920s, S.S. Kresge Company began opening locations, featuring items for $1 or less in so-called green-front stores that were often next door to the traditional red-front five-and-dimes. By the 1950s, retailing was changing. So, too, was Kresge's. It soon ventured onto a path transforming itself into Kmart. By 1977, almost 95 percent of Kresge sales were generated by Kmart, leading to the name change of the company. A decade later, Kmart sold off its remaining Kresge stores. (Courtesy of the Paterson Museum.)

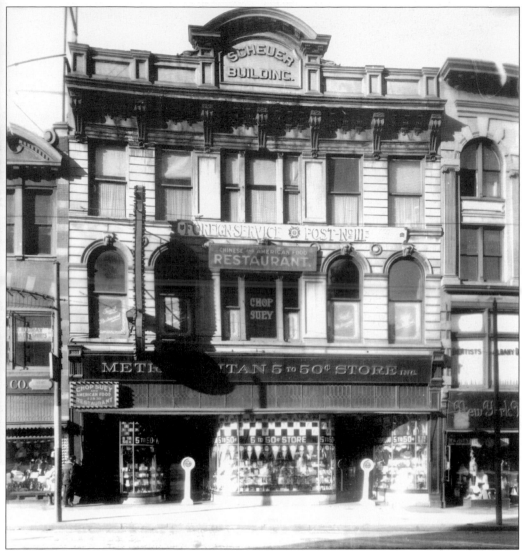

At the Metropolitan store, you could grab a quick gift or check your weight on one of the outdoor scales. You could stop at the Scheuer building for some chop suey. You could even drop by for some camaraderie at the foreign service post.

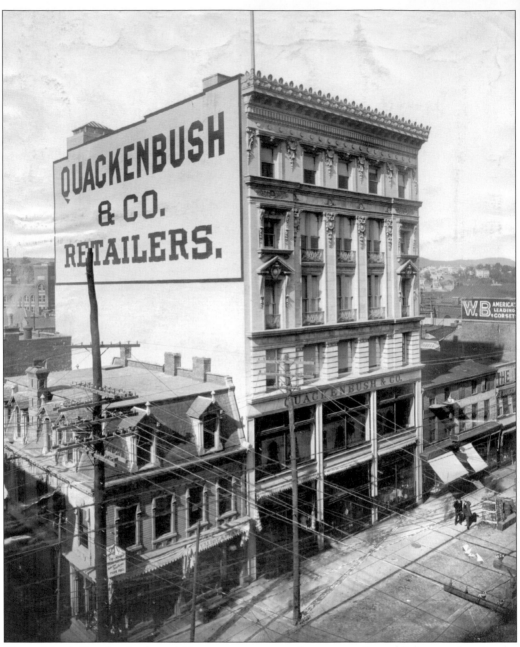

The original Quackenbush and Company was one of many retail establishments lost in the Great Fire of 1902. Also on the long list were Michaelson's, the Jackson Piano Company, and Thomas Green Furniture.

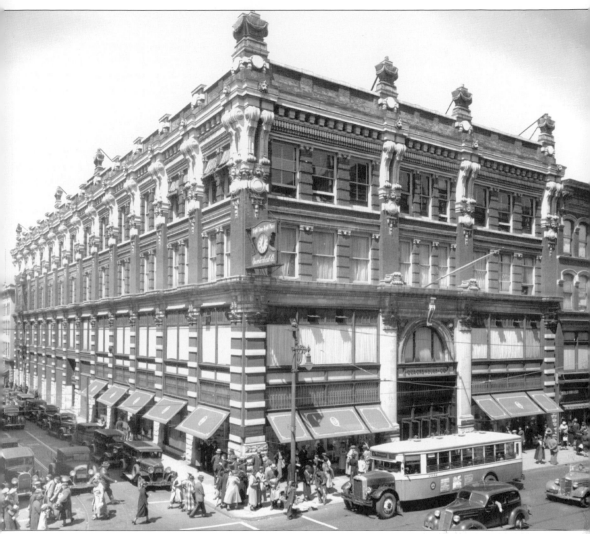

"Right Time, Right Place" was the slogan at Quackenbush and Company. In its 1947 Gift Week sale on Thanksgiving—the kickoff to the Christmas shopping season—it advertised revolving Ty-Master tie racks for a mere 89¢, a 24-sheet set of boxed stationery for 19¢, and an alarm clock for $1.69. The specials, however, were for two days only. Two years later, "Paterson's First Department Store" advertised a 9- by 12-foot Karastan rug for $152.50, available for the taking at its third-floor floor-coverings department with just 10 percent down.

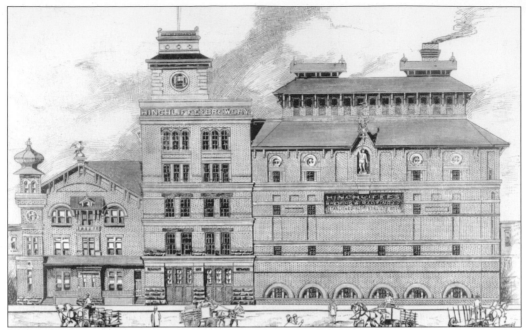

The Hinchliffe Brewing Company was founded by John Hinchliffe, who was born in Yorkshire, England. His Paterson-born son, William Fitzgerald Hinchliffe, carried on the family business for 35 years until his death in 1913, giving special attention to the brewing of ale and porter. The Hinchliffe plant became famous. As for the competition, there was C. Braun's Lager Beer Brewery. (Courtesy of the Paterson Museum.)

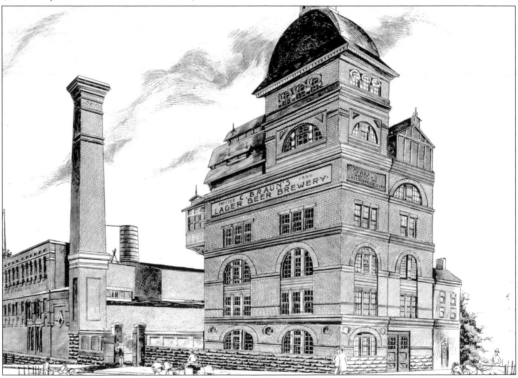

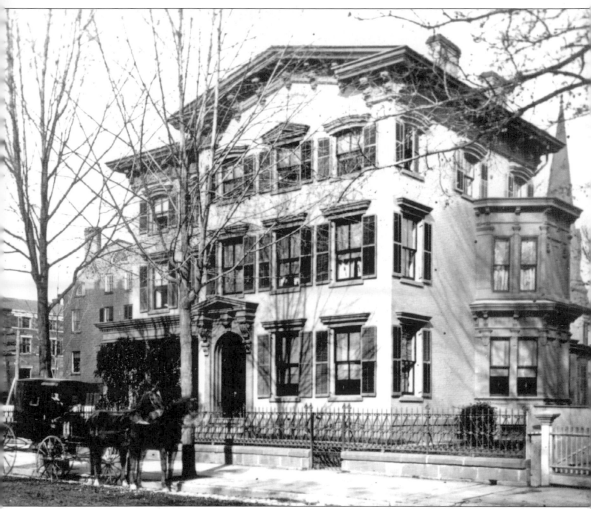

In 1892, Sarah A. Cooke donated her house on Ellison Street to serve as Paterson's first YMCA in memory of her husband, John Cooke of Danforth, Cooke and Company, famed locomotive makers. (Courtesy of the Paterson Museum.)

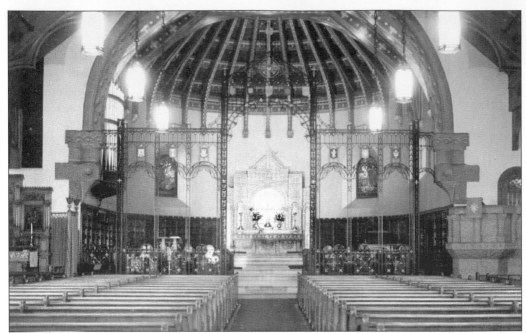

Patterned after Durham Cathedral in England, St. Paul's Episcopal Church was built on what was largely farmland in 1897 at Broadway and Eighteenth Street. Its pink granite came from the Pompton Quarry. The wainscoting and pews were made of oak, and Tiffany created 12 of its windows, with the others coming from the "old" 1851 church. The church's roots in Paterson date from 1817. During the 1895–1938 tenure of the "new" church's first rector, Rev. David Hamilton, the communicant list grew from 250 to more than 2,000, making it the 10th largest Episcopal congregation in the United States.

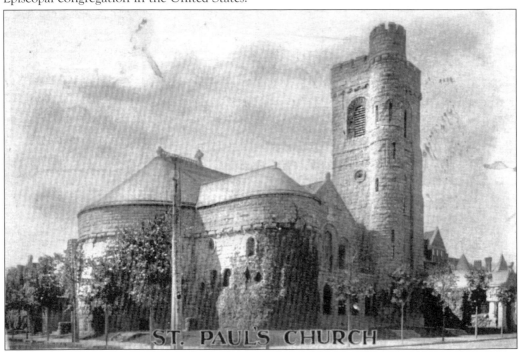

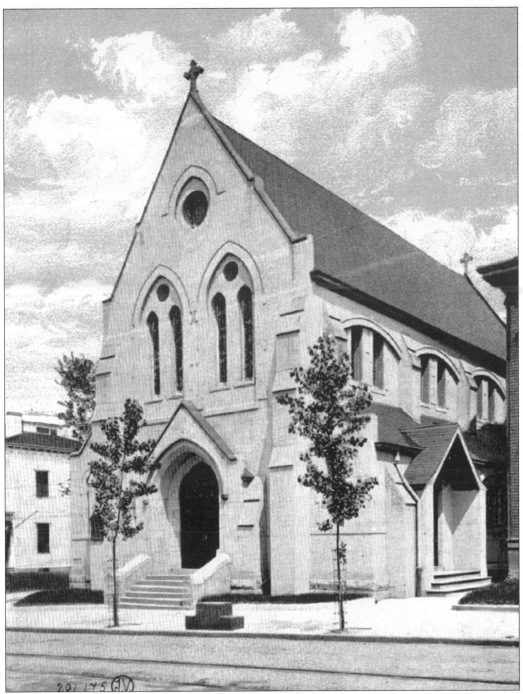

In 1920, St. Mark's Episcopal Church was the youngest of Paterson's five Episcopal churches, having held its first service in 1894 at the old St. Paul's Sunday School. That building was lost in the Great Fire of 1902, leading to the building of this edifice from 1904 to 1905 at Broadway and Straight Street. The first rector, William P. Evans (1894–1900), shared time in Clifton, helping an infant parish by the name of St. Peter's begin its mission in that neighboring city. He conducted the first service of St. Peter's in 1896.

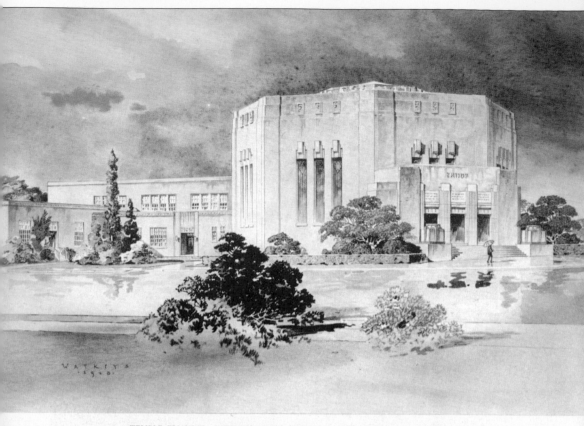

TEMPLE EMANUEL, PATERSON, NEW JERSEY—F. W. WENTWORTH, ARCHITECT

FROM A WATER COLOR RENDERING BY PAUL F. WATKEYS

The octagonal Temple Emanuel mirrored the appearance of Chicago's Isaiah Temple, at the suggestion of movie-house magnate Jacob Fabian, according to the *Paterson Morning Call* of September 7, 1926, in which this rendering appeared. As with so many other Paterson buildings, the architect was Fred W. Wentworth. The temple, at Broadway and East Thirty-third Street, itself would seat 1,400. By the late 1940s, Paterson's Jewish population had risen to about 30,000. In June 1935, the temple marked its first Hebrew School graduation. The burning of the mortgage came in October 1944. In March 1965, the Hebrew School was featured in a four-part NBC series titled "The Fourth Jewish R." In the ensuing years, however, the congregants began moving on. In 1995, the congregation voted to leave Paterson for Franklin Lakes. "There's some rancor involved, a little sadness," Rabbi Sylan Kamens said at the time, "but a recognition that you have to move on and go forward."

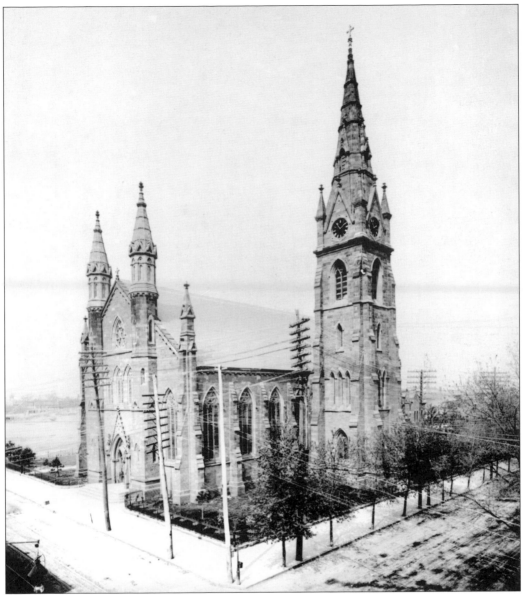

The Roman Catholic Cathedral of St. John's is a Gothic-style church built of brownstone hauled from Little Falls via the Morris Canal. It is on the state and national lists of historic sites and was consecrated in 1890. "By its position 'on Main and Grand' directly in front of the Colt mansion, the home of the governor of the S.U.M, and by its dominance of the Paterson skyline, St. John's made a grand statement about the position of the church and the congregation in the life of the new nation and the city," wrote Raymond J. Kupke in *Living Stones: A History of the Catholic Church in the Diocese of Paterson*. (Courtesy of the Paterson Museum.)

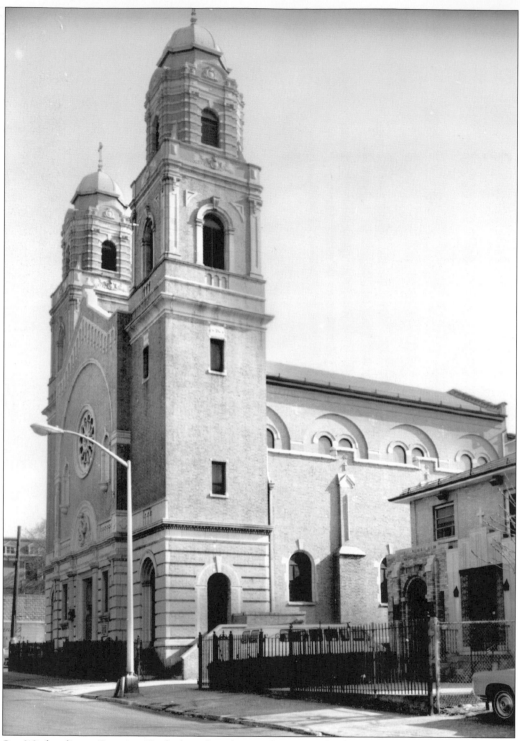

St. Michael's, a Roman Catholic church on Cianci and Elm Streets, sports twin-domed campaniles and is similar to Spanish Colonial churches found in the Southwest. It is a state and federal historic site. (Courtesy of the Paterson Museum.)

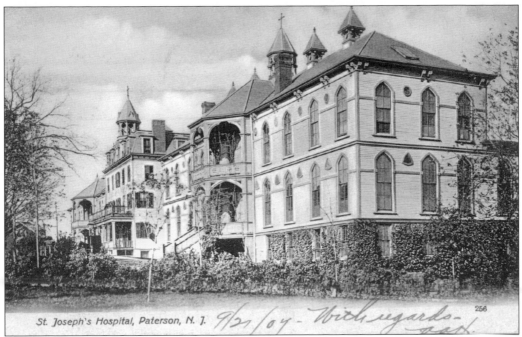

St. Joseph's Hospital, Paterson, N. J. 9/21/04 - With regards -

It took some ingenuity on the part of the Sisters of St. Elizabeth to make St. Joseph's Hospital a reality back in 1867. They took in laundry. They farmed. They even begged at street corners. It was all to make ends meet in that first year, when they cared for 102 patients, mostly laborers and the poor who had no where else to turn. Today, the 792-bed medical center hosts one of New Jersey's premier children's hospitals. The facility is shown here in a 1904 postcard and in a 1920s photograph. (Courtesy of the Paterson Museum and the Richard Walter collection.)

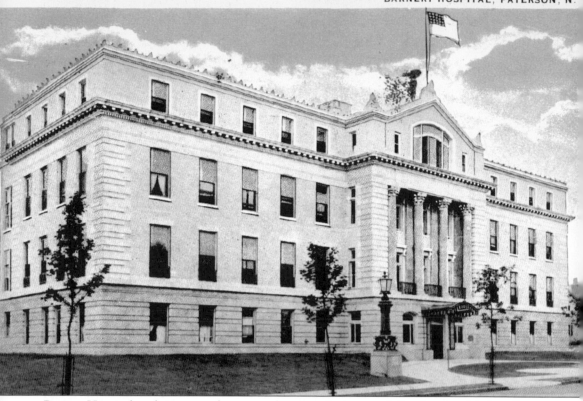

Barnert Hospital took its name from one of Paterson's greatest philanthropists, Nathan Barnert, who served as mayor from 1883 to 1886. The Prussia-born Barnert—whose youthful exploits took him to California amid the gold rush—eventually settled in Paterson and entered the tailoring business on Main Street, soon capturing large contracts for Union uniforms with the advent of the Civil War. Later, he invested in real estate, something that would help cement his fortune. Of his public life, he had this to say: "Public office has no charm for me. To be serviceable to the people who have put their trust in me as executive is my aim." They were not empty words. Each month, in fact, he gave his salary as mayor to the hospitals and the poor, irrespective of creed, according to *Paterson and Its Environs*. (Courtesy of the Richard Walter collection.)

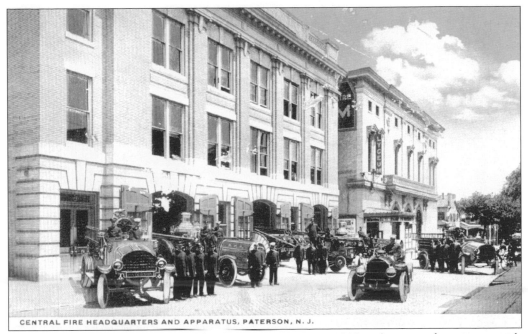

The Central Firehouse and its wealth of apparatus is seen *c.* 1918 and in an earlier picture with aerial truck No. 2. Paterson had a role in the early days of horse-drawn steam fire engines, with Richard Harrell building his first in 1869 from the designs of John Nichols, master workman at Grant Locomotive Works.

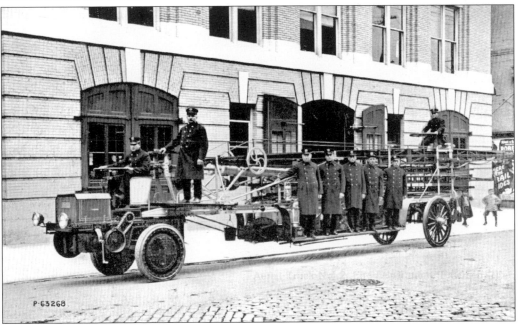

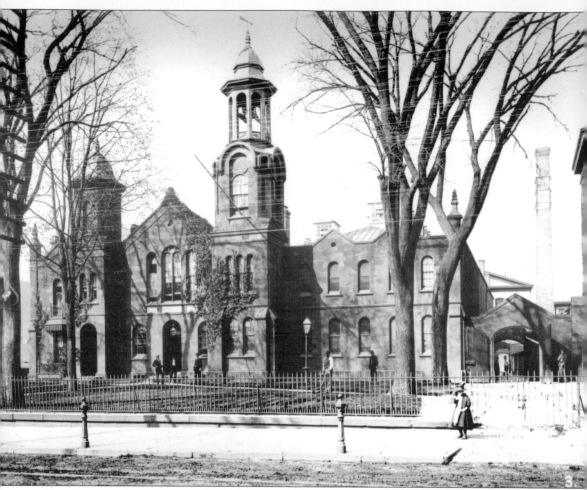

Upon being admitted to the c. 1859 Passaic County Jail, one prisoner was reported to have remarked, "I've been passing it all my life, and I thought it was a church." The ever-expanding jail (wings were added in 1880) was the scene of a double hanging in 1905. As for the inmates, they were kept occupied breaking up rocks sent down from Garret Mountain for use in road construction. By 1955, when the jail was razed to make room for a new one, this was the typical fare: bread, butter, and jelly for breakfast; roast beef, meat loaf, or spaghetti and meatballs for lunch; and sandwiches for dinner. (Courtesy of the Paterson Museum.)

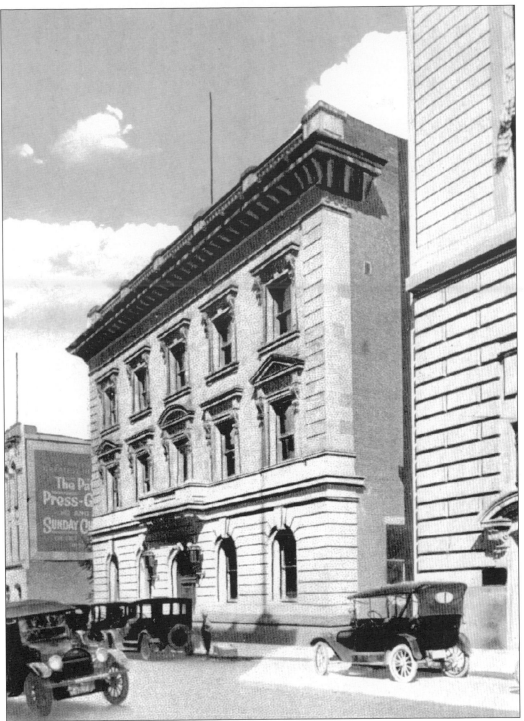

Shown in this photograph is Paterson's police headquarters. Paterson was the birthplace of the modern-day submarine, the Colt revolver, and the Patrolmen's Benevolent Association (in 1896). The association's first president was James Evers, a career patrolman. (Courtesy of the Richard Walter collection.)

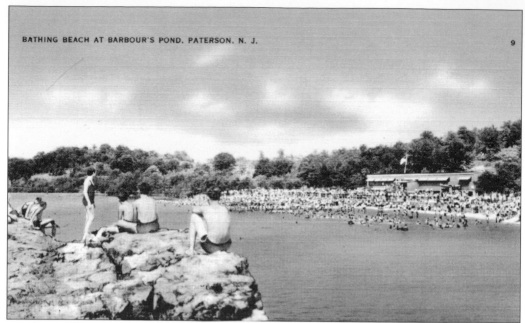

Besides the beauty and allure of the Great Falls, there was the Passaic River itself, twisting through Paterson. Also, there was the bathing beach at Barbour's Pond. Still, some Paterson residents needed more than a beach. They needed the Jersey Shore. As far back as 1927, people would go to the Alexander Hamilton Hotel to depart on a parlor car bus for Asbury Park. They would depart four times a day, picking up passengers for the return trip at Asbury Park's Ansonia Hotel. The fare was $2 one way.

A Place in History

*Taking it collectively, the men of Paterson are citizens to be proud of, and in every
emergency they have proven themselves to be heroes, ready and willing
to risk their own lives in the preservation of the lives and property of others.*

—*Paterson Evening News*, March 4, 1902, on the occasion of the great flood.

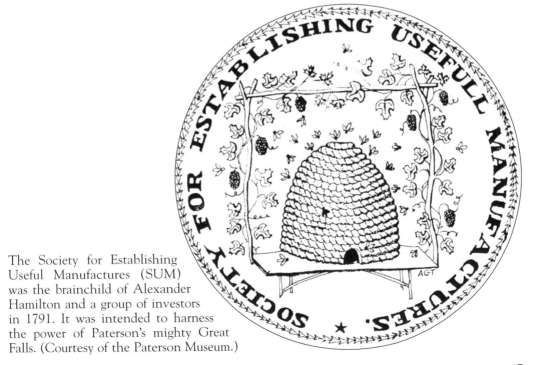

The Society for Establishing
Useful Manufactures (SUM)
was the brainchild of Alexander
Hamilton and a group of investors
in 1791. It was intended to harness
the power of Paterson's mighty Great
Falls. (Courtesy of the Paterson Museum.)

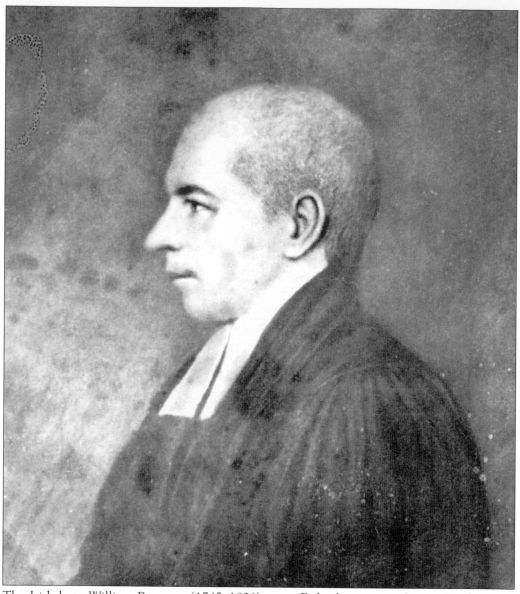

The Irish-born William Paterson (1745–1806) was a Federalist, as was George Washington. He was one of the state's first two senators and was then its governor. He was an associate justice of the U.S. Supreme Court. However, his backing for the Society for Establishing Useful Manufactures in the state's assembly was said to have returned that enduring piece of gratitude. The society chose to give its city the name Paterson. (Courtesy of the Paterson Museum.)

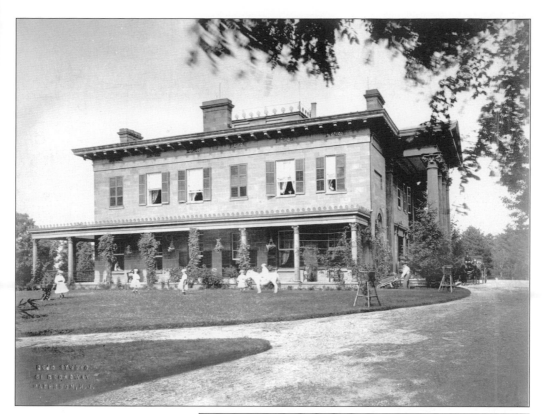

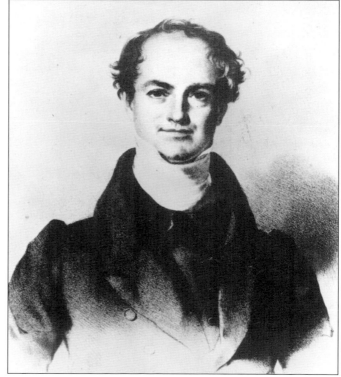

The Colt family is seen outside the "office of the governor" (in this case of the SUM) in a photograph taken *c.* 1855 by John Reid. Roswell L. Colt, son of raceway architect Peter Colt, lived from 1779 to 1856, yet his substantial Colonial mansion at Colt's Hill, a small hill at Main and Grand Streets, survived for 35 more years. A marital dispute over the home's location led to the breakup of his marriage with his wife, Margaret, taking 6 of their 10 children to Europe. Roswell was said to have entertained Daniel Webster at Colt's Hill. It was Roswell Colt's cousin Sam who would eventually cement the family's name in history as producers of the gun that won the West. (Courtesy of the Paterson Museum.)

Known as the father of the American silk industry, John Ryle, already an experienced silk weaver in his native Macclesfield, England, came to the United States in 1839. "It was through his knowledge, together with intellectual forethought, that the manufacturer of silk is as extensive as it is today in Paterson," wrote the author of *Paterson and Its Environs* in the early 20th century. Many would follow in Ryle's footsteps. By 1897, some 15,000 people from Macclesfield would come to booming Paterson. (Courtesy of the Passaic County Historical Society.)

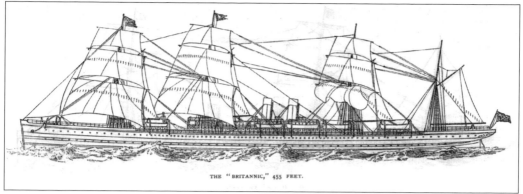

THE "BRITANNIC," 455 FEET.

The Landing at Liverpool—shown here in an 1885 engraving from *Frank Leslie's Sunday Magazine*—was the departure point for many an English silk weaver seeking better employment opportunities in Paterson. Many found themselves on such ships as the *Britannic*. On one *Britannic* voyage in 1895, Emily Broadhurst and her three children—Harriet Alice, Ada, and Frederick—began the trek from their home on High Street in Macclesfield, setting up house at 74 Oak Street in Paterson. Harriet Alice eventually met William Marsden Read, who was nine years old when his family arrived from Macclesfield in 1886. They married and set up lodgings a few doors down at 67 Oak Street. Six children followed. Harriet's mother, Emily, lived to be 93 and is buried at Cedar Lawn Cemetery.

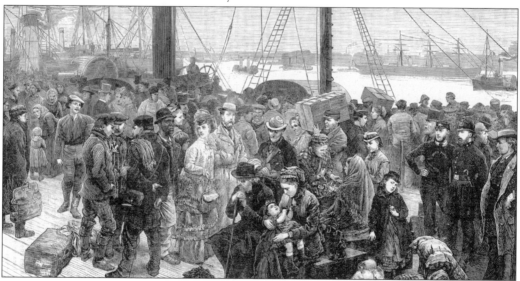

VALUABLE FREEHOLD SILK FACTORY & PROPERTY,

IN CHESTERGATE AND KING EDWARD STREET, MACCLESFIELD.

TO BE SOLD BY AUCTION,

BY MR. KNIGHT,

AT THE "ANGEL INN," MACCLESFIELD,

ON THURSDAY, THE 28th OF JULY, 1859,

AT SEVEN O'CLOCK IN THE EVENING SUBJECT TO SUCH CONDITIONS AS SHALL BE THEN PRODUCED:

LOT 1—ALL THAT

SILK FACTORY

WAREHOUSE, AND PREMISES,

Fronting to Chestergate, and extending into King Edward Street, in Macclesfield aforesaid, being three stories high, and now, or late in the occupation of Peter Moll and Co., Mr. Thomas Wheelton, and Mr. William Davenport.

LOT 2.—ALL THOSE FIVE

Messuages, or Dwelling-Houses & Shops,

Fronting to King Edward Street aforesaid, and adjoining Lot. 1, together with the Yard, Outoffices, and premises, now in the respective occupations of James Smith, Thomas Wadsworth, Mary Ann Smith, and Elizabeth Longshaw.

This Property is Freehold of Inheritance, and is in an excellent situation. There is a well in the yard belonging to the Factory, capable of supplying a steam engine with water. The Houses are modern and very substantially built.

For further particulars apply to Mr. James Dewhurst, the Owner; or to the Auctioneer, or at the offices of Messrs. Parrott, Colville, and May, Solicitors, Macclesfield.

M. BURGESS, PRINTER, MARKET PLACE, MACCLESFIELD.

The silk industry in Macclesfield, England, had its ups and downs, as evidenced by this auction of a silk factory's contents in 1859. England would soon drop tariff protections for its domestic silk industry, resulting in cheaper silk imports from France. The fallout was felt in a wave of new immigrants to Paterson. Today, there is a silk museum in Macclesfield featuring an exhibit on Paterson.

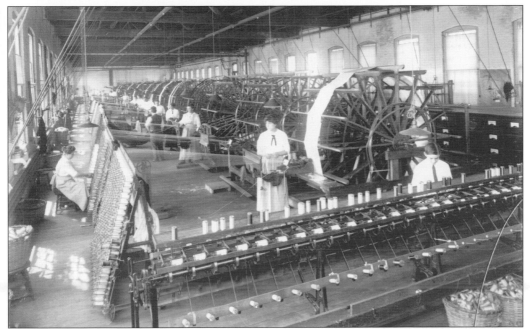

The workplace in the silk mills included women and children, as seen in these interior views. Among the early silk manufacturers were Henry Doherty and Joseph Wadsworth, two expert silk weavers who came to Paterson from Macclesfield, England, shortly after the Civil War. By 1879, they teamed up as Doherty and Wadsworth, soon employing nearly 200 and joining the likes of the William Strange Company, Dexter and Lambert, and Phoenix Manufacturing. In 1938, one newspaper remarked on the firm's staying power: "None of these noted silk manufacturing firms of the '70s and '80s survived competition of later years. Doherty and Wadsworth is about the only old familiar name that remains of those early silk manufacturers."

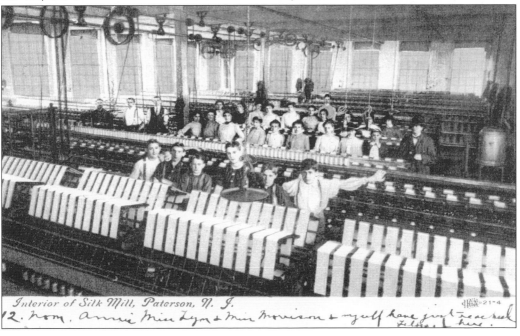

Interior of Silk Mill, Paterson, N. J.

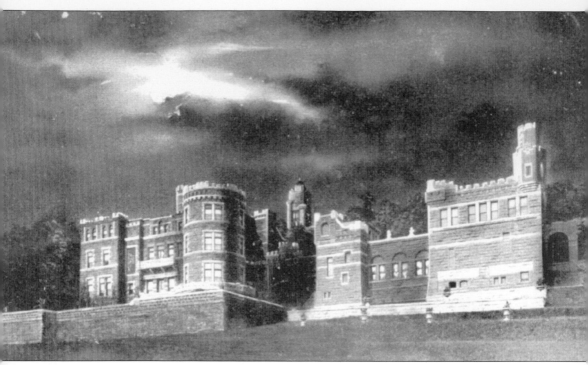

Lambert Castle was called Belle Vista in honor of Catholina Lambert's wife, Isabella, when the family settled in during 1893. The castle was said to resemble Warwick Castle in Lambert's native England. Apparently, it was not by coincidence. As the story goes, a young Lambert often delivered goods to Warwick Castle as a poor delivery boy before finding success in America. Lambert began his journey toward success at the age of 17 and would live to be nearly 89, dying at Belle Vista on February 15, 1923. (Courtesy of the Paterson Museum.)

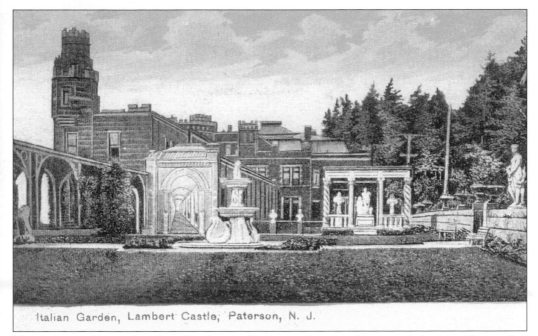

The Italian garden at Lambert Castle stood between the main house and the wing devoted to Catholina Lambert's substantial art collection. Lambert faced financial difficulties after the labor unrest of 1913. In 1916, the Lambert art collection—365 pictures and numerous pieces of statuary—were auctioned off in the Grand Ballroom of New York's Plaza Hotel. They brought in just over $592,000—about a third of their purported value.

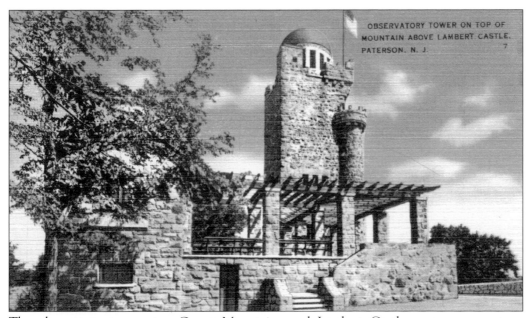

The observatory tower atop Garret Mountain—and Lambert Castle—was an opportune vantage point for silk magnate Catholina Lambert to spot ships carrying his goods arriving via the port of New York.

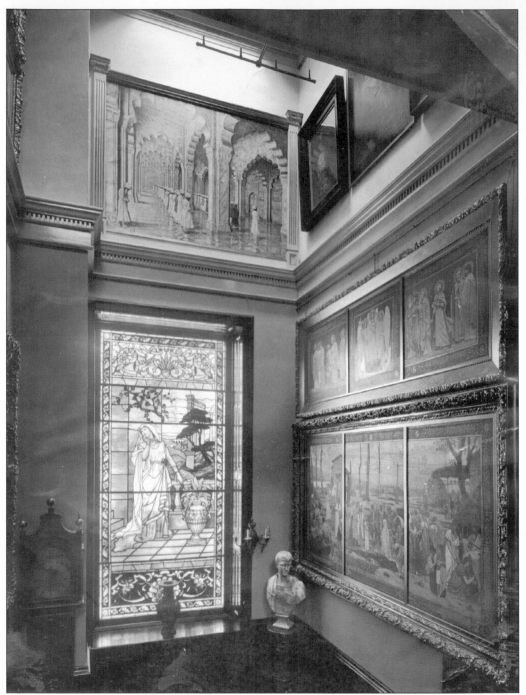

In the stairwell of Lambert Castle is a large stained-glass window that is a memorial to Lambert's first child, Florence. The Lambert daughter was 24 years old when she died in 1883, yet she lived longer than many of her siblings. Of Catholina Lambert's eight children, seven predeceased him. Many died as children. Today, the newly restored Lambert Castle houses an array of early paintings and photographs, as well as a genealogy library operated by the Passaic County Historical Society. (Courtesy of the Paterson Museum.)

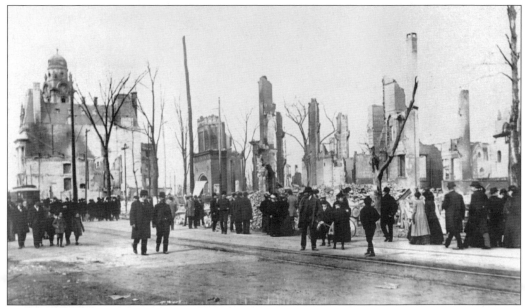

It was February 8, 1902, when a wind-whipped fire at the trolley sheds on Broadway near Mulberry Street consumed Paterson City Hall, banks, churches, homes, and even the library and its 37,000 volumes. Some 500 families lost their homes, which then lay in ruins. "Conflagration cuts a wide swath through city's business district," read the headline in the February 10 edition of the *Paterson Guardian* over a block-by-block accounting of the losses. Note the top of city hall, above, in the top left. The famed Hamilton Club, a social meeting place for the city's well-to-do, was also badly damaged. (Courtesy of the Paterson Museum.)

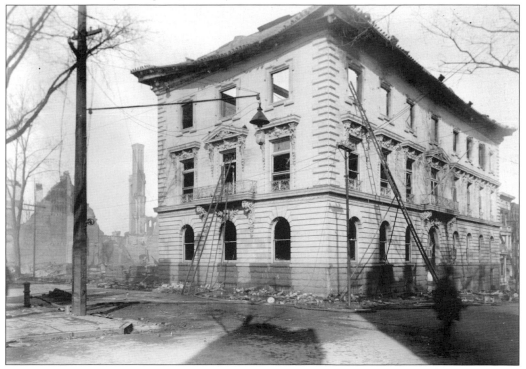

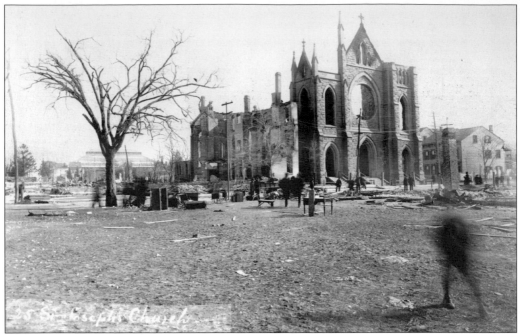

Looking like a small-scale Notre Dame, St. Joseph's Roman Catholic Church stands at Market and Carroll Streets after the Great Fire of 1902. Inside its doors today are stained-glass windows from Ireland and a main altar with a relief of Leonardo da Vinci's *Last Supper*, carved by Paterson's own Gaetano Federici. (Courtesy of the Richard Walter collection.)

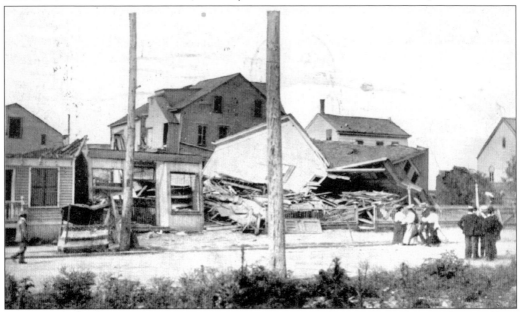

The tornado of 1903 started out on Valley Road across from Lambert Castle, on what was then Lambert acreage called Maplewood. It touched down on Barclay and Marshall Streets. Among its hits was Clay Street (Twenty-first Avenue) at Straight Street, where some 100 buildings were damaged. By day's end on that July 22, three were dead and hundreds injured after the tornado cut a powerful swath through the city. (Courtesy of the Richard Walter collection.)

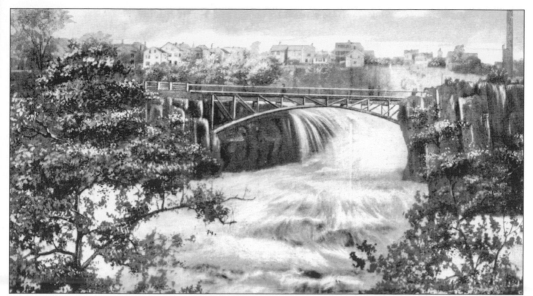

The great flood, particularly painful because it came so shortly after the Great Fire of 1902, unleashed a torrent of water on Paterson, dramatically increasing the display of the falls but also putting such businesses as the Bijou Hotel and Restaurant under water. Property losses were put at $1 million. The day's press report carried this harrowing account of a crossing with the river's waters several inches above a bridge's surface: "Despite the protests of his companion, the man insisted on attempting to cross the bridge. The horse balked at stepping into the swiftly moving waters, but was lashed with the whip by the driver until it went ahead. The animal had gone about 50 feet when the strong current overbalanced it and the animal fell. The woman, screaming with terror, jumped from the carriage onto the bridge and grasped tightly the iron supports in the center. Her companion stuck to the buggy lashing the horse furiously and was swept over the south side of the structure still seated in the rig. The awful swirl of the water covered horse, wagon and driver, and they were seen no more."

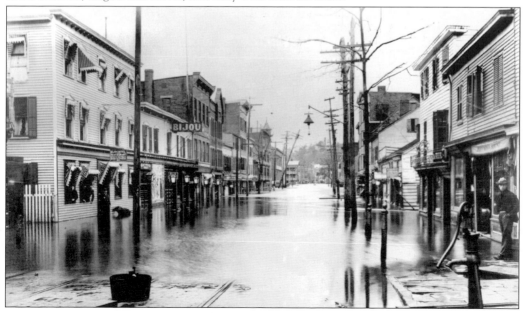

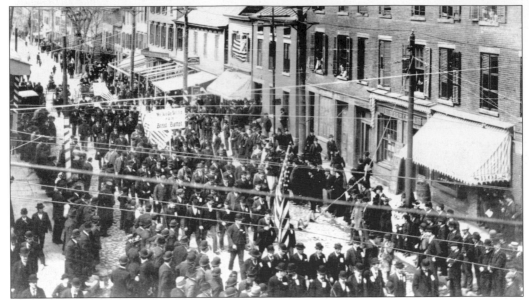

"We are on strike for bread and water," reads the banner in what was one of Paterson's defining moments. The 1913 walkout—whose leaders included "Big Bill" Haywood and Elizabeth Gurley Flynn—marked the beginning of a decade-long series of labor incidents that culminated in the rapid decline of the silk industry. Of that 1913 strike, John Reed wrote in *The Masses*, "There's war in Paterson. But it's a curious kind of war. All the violence is the work of one side—the mill owners. Their servants, the police, club unresisting men and women and ride down law-abiding crowds on horseback. . . .They control absolutely the police, the press, the courts." Later, Reed, the Harvard-educated son of wealthy parents, wrote an account of the Bolshevik Revolution, *Ten Days That Shook the World*. The ashes of Reed, like those of Hayward and Flynn, were buried in the Kremlin Wall in Moscow. (Courtesy of the Paterson Museum and the Richard Walter collection.)

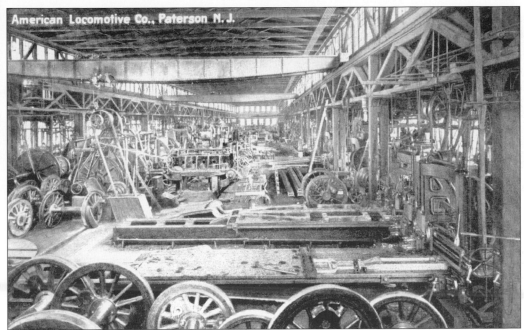

In the end, there was one: the American Locomotive Company. It became the last standing after the era of Paterson's big three iron horse makers—Rogers, Cooke, and Grant—came to an end in what was once known as "the Capital of the Railroad World." However, it was not always that way. Demand for Rogers Locomotive Works engines was so great during the Civil War that it was producing 10 to 12 a month. A Grant locomotive won a grand gold medal at the 1867 Paris International Exhibition, if only for its elaborate polished metal and beauty. By 1885, Grant would fail. In 1902, Cooke was absorbed by the American Locomotive Company, as was Rogers (below) just two years later.

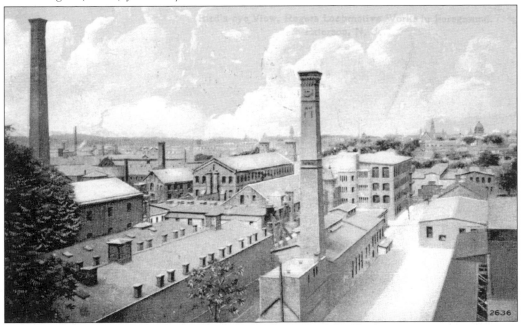

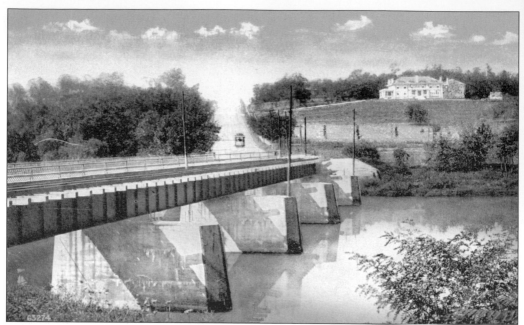

Perhaps the largest estate in Paterson outside Lambert Castle, the Barbour mansion today has 42 rooms, 12 fireplaces, and a library on five acres at Thirty-ninth Street between Broadway and Eleventh Avenue. The mansion—known in its day as Kilbarchen after the family's ancestral home in Scotland—was home to John Edwards Barbour, the son of Robert Barbour, who founded the linen thread industry in Paterson in 1864. Originally, the estate covered 60 acres running all the way to the Passaic River. When the Barbour family lived there, it had a staff of 20 servants to keep things in order. The estate was listed for sale in 2002 for $1.5 million. (Courtesy of the Richard Walter collection.)

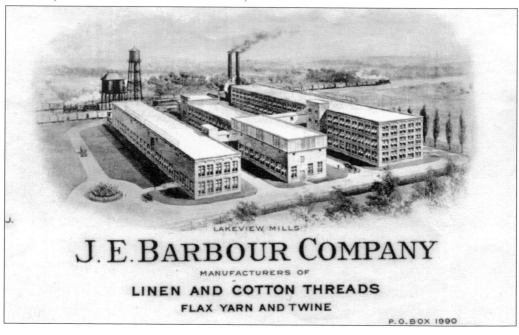

LAKEVIEW MILLS

J. E. BARBOUR COMPANY

MANUFACTURERS OF

LINEN AND COTTON THREADS

FLAX YARN AND TWINE

P. O. BOX 1990

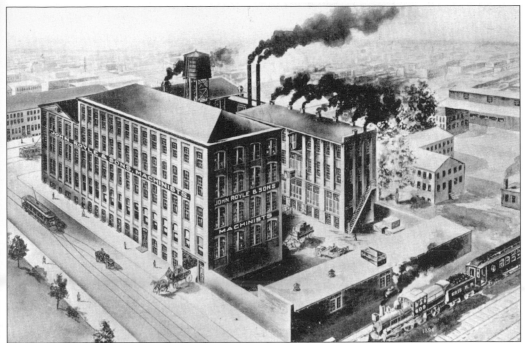

The Royle router, which could hum its way through cooper, zinc, and brass at up to 20,000 revolutions per minute, eventually became the world standard. Vernon Royle, the eldest son, handled the business management of John Royle and Sons Machinists (above) but was soon at work perfecting the router. The fine-tuning of such mechanical devices was crucial to the success of industry in Paterson, since they were tools to lessen labor and to make production cheaper. In later years, Vernon's son Vernon E. Royle stayed associated with the industry founded by his grandfather. He made his home at 399 Fifteenth Avenue. (Courtesy of the Richard Walter collection.)

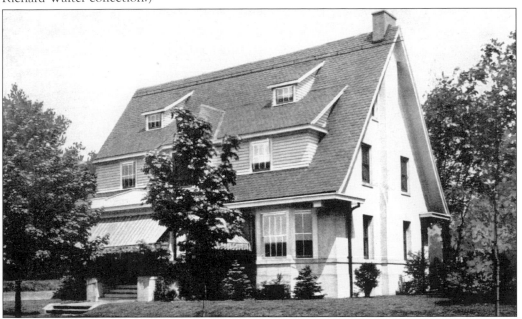

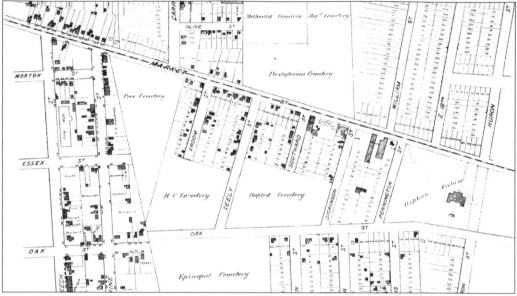

On land now home to Eastside High School's football team, the Ghosts, once stood a portion of the Sandy Hill Cemeteries dating from 1814. The Episcopal Cemetery ran along Paterson's Oak Street near Martin Street. On the opposite side of Oak Street, there were cemeteries for Roman Catholics and Baptists. Nearby, the Methodists, Presbyterians, and Dutch Reformed ones could be found sandwiched between Market and Willis (now Park) Streets. By the late 1880s, neglect had set in, and newer Victorian burial grounds such as Cedar Lawn Cemetery had been created. "They became a rambling ground and pasture for cattle, goats, pigs, and other domestic animals," a member of the Burial Ground Protective Association wrote at the time. "Children jumped and played and made a sliding place of the steep sand embankment at its easterly boundary, and it was almost a daily occurrence to see bones of somebody's loved one come rolling down the sandy bank." The passage was highlighted in Howard D. Lanza's *Gateway to the Past: A Guide to Cedar Lawn Cemetery*. Sandy Hill was condemned in 1914, and the bodies were moved to other cemeteries. (Courtesy of the Paterson Museum.)

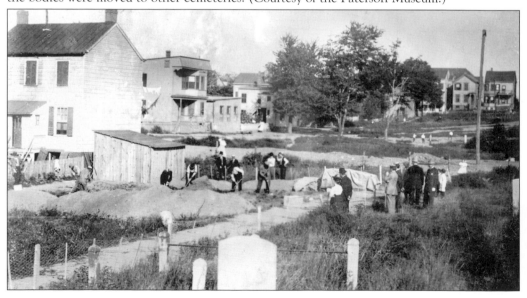

Three

IN THE NEWS

He is coming here in peace. This is good for the people of Paterson.
He wants to keep us organized. He wants to give us hope.

—Mary Williams at the March 1968 visit of Rev. Martin Luther King Jr.

John Philip Holland, an Irish-born "little professor" who wound up teaching at St. John's Parochial School in Paterson, is believed to have first leaked word of his May 22, 1878 test of the *Holland I* to his young charges, who, in turn, let their parents know. On the day of the fateful launch, Holland apparently miscalculated the small vessel's buoyancy, and the unmanned sub slipped to the bottom, only to be resurfaced by strong pulls on the towlines. By May 29, however, the ballast tank pressure was adjusted, and the world's first motorized submarine underwent successful trials. Come June 6, in the presence of his financial backers, Holland dived to an estimated 12 feet below the surface of the Passaic River. He quickly surfaced, smiling. He then took it down again, this time for such a lengthy time that onlookers became more concerned. Again, he appeared. The day's events were deemed a success, and the small *Holland I*, having served its purpose, was towed to deeper water and scuttled just above the Spruce Street Bridge. (Courtesy of the Paterson Museum.)

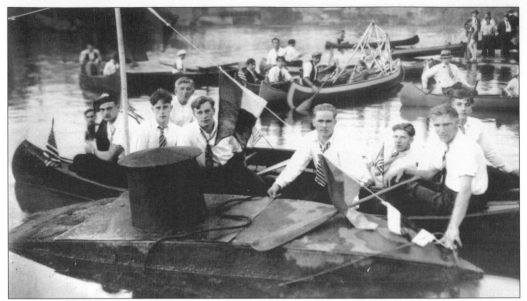

At Paterson's Spruce Street Bridge is a plaque that tells of these boys' exploits in 1927: "John P. Holland's first submarine was launched in 1878—a one man craft with engine which after a series of trials was sunk in the Passaic River at this spot, where she lay buried until raised in 1927 by a group of Paterson youths who presented her to the city of Paterson, October 1, 1927. This tablet was placed in the year 1932 by the Passaic County Board of Chosen Freeholders in cooperation with the Passaic County Historical Society." *Holland I* is on display at the Paterson Museum. (Courtesy of the Paterson Museum.)

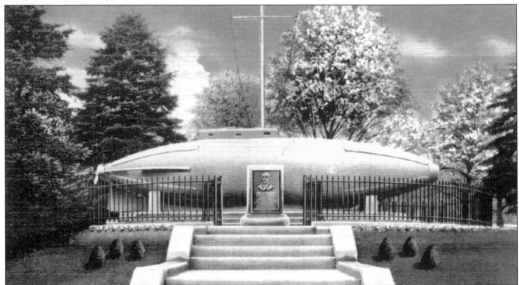

Holland went on to build a much larger submarine after those first tests in 1878, ones that eventually led to the U.S. Navy embracing the Holland submarine as its standard-bearer. The *Holland II*, once displayed in Paterson's Westside Park, is now on display at the Paterson Museum. In Holland's 1914 obituary in the *New York Times*, it was said, "Although he was interested in submarines, Mr. Holland was opposed to war, and his idea of submarines was to incapacitate warships and not to destroy them and kill the men inside."

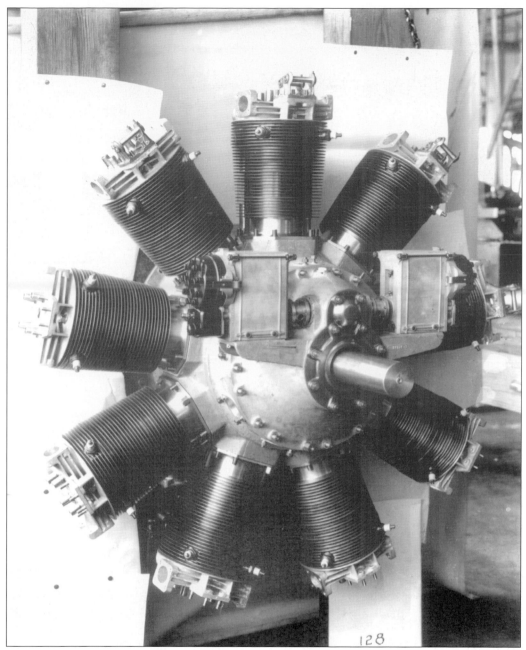

128

During Charles A. Lindbergh's solo flight across the Atlantic in 1927, the *Spirit of St. Louis* was powered by a Paterson-made Wright Whirlwind, an air-cooled powerhouse that had fuel economy and lightness. Wright engines would go on to other firsts, powering B-17s, B-29s, and B-25s during World War II. By 1985, the 58th anniversary of Lindbergh's history-making flight, a plaque was dedicated at the factory on Lindbergh Place (Lewis Street) in a ceremony with Mayor Frank X. Graves Jr. and Rep. Robert A. Roe. A vintage aircraft flew overhead, transporting the gathered crowd back in time. (Courtesy of the Paterson Museum.)

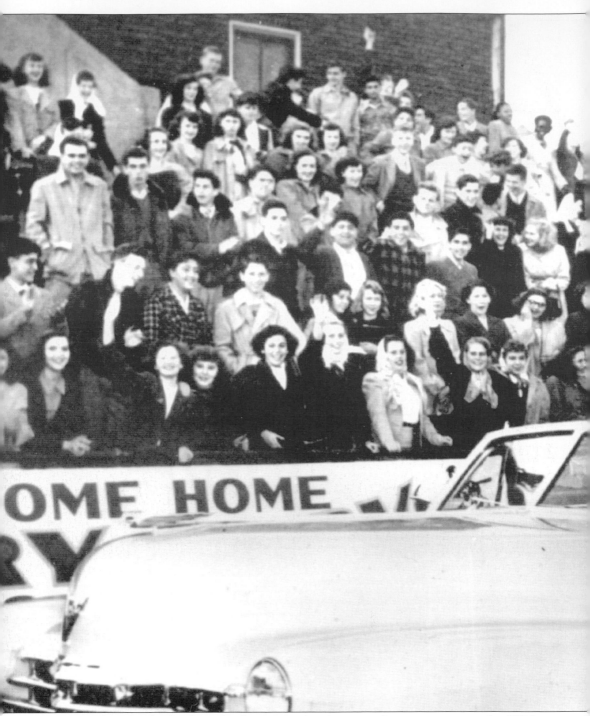

Larry Doby, who broke the color barrier in the American League, waves to the "Welcome Home" crowd in Paterson. "The kid from Paterson, N.J., is on the high road to glory," read a headline on a *Sport* magazine article by Doc Young, sports editor of the *Los Angeles Sentinel* shortly after the fleet-footed center fielder helped propel the 1948 Cleveland Indians to their first World Series victory in 28 years. After a tough first season the year before, Young wrote,

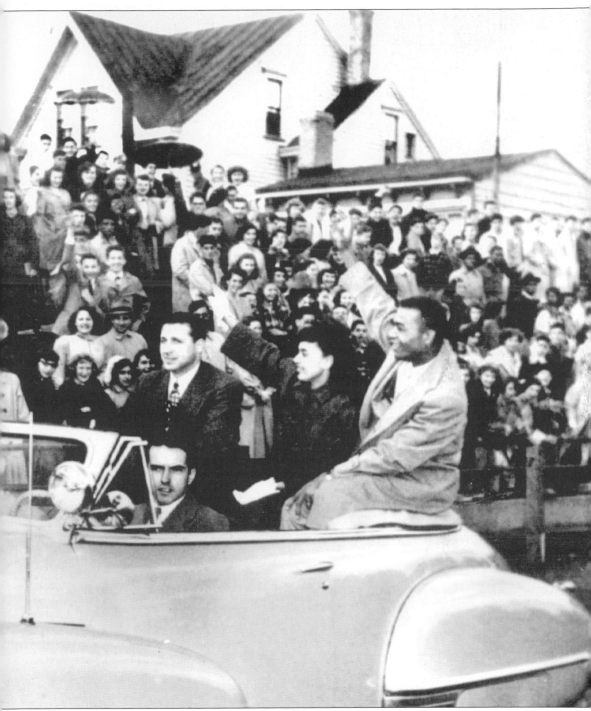

"The Negro outfielder . . . had led the Tribe down the homestretch with his heavy hitting and had kept up the pace in the Series, topping his team in battling with a neat .318 average against the (Boston) Braves." It was a tough road for this "loner" who was viewed as an "intruder" his first year, Young wrote. Doby finished the season batting .301, with 14 home runs, 64 runs battled in, and 80 runs scored to his credit. (Courtesy of the Richard Walter collection.)

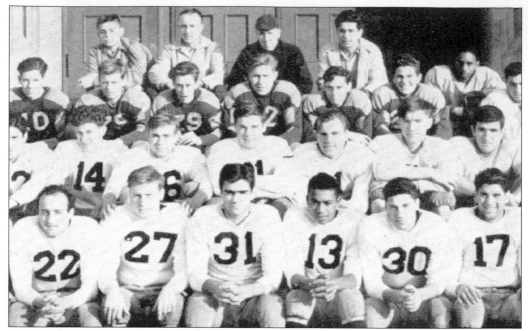

Larry Doby knew more than baseball. Here he is in his No. 13 football jersey at Paterson's Eastside High School, where he starred in track, football, basketball, and baseball. He was named class athlete in his yearbook, the 1942 *Senior Mirror*. Doby eventually married his high-school sweetheart, Helyn Curvy.

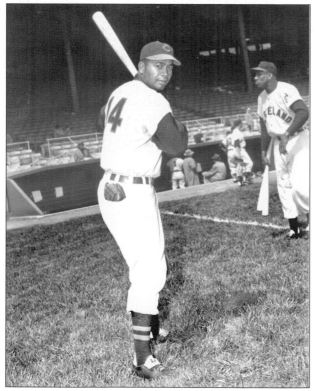

With the 1948 World Series victory secured, Doc Young of the *Los Angeles Sentinel* had this to say about Cleveland Indians player Larry Doby: "The future is indeed bright for Larry Doby—the shy guy who became brash at bat, the quiet lad who took the knocks for a long time and then had the guts to come back from the depths of near-defeat, the fellow you might mistake for a clean-cut college lad instead of a colorful ballplayer." (Courtesy of the Paterson Museum.)

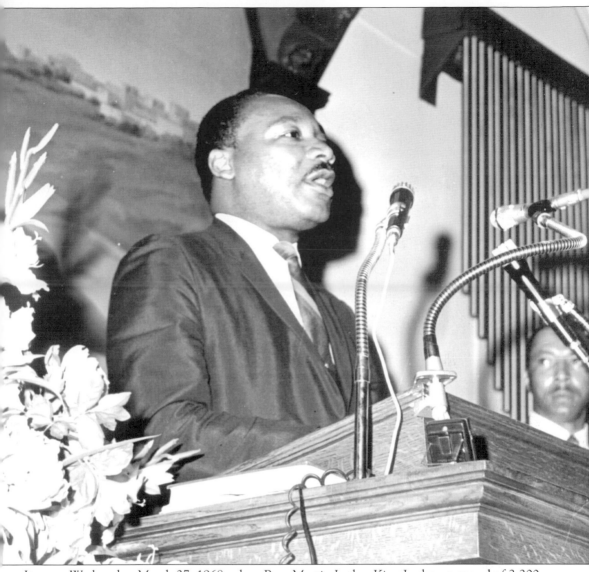

It was a Wednesday, March 27, 1968, when Rev. Martin Luther King Jr. drew a crowd of 2,200 at Paterson's Community Baptist Church. Although he was two hours late (it was the seventh stop of his day) and spoke for only five minutes, King carried a message for people to join his "poor people's march" on Washington, D.C., come April 22. "It's a shame that this nation, wealthiest in the history of the world, has 40 million poor people. We are going to Washington, seat of this government, to dramatize the horrors and evils of poverty." Within three months, the nation's most successful advocate of nonviolent change would fall to an assassin's bullet. (Courtesy of the Paterson Museum.)

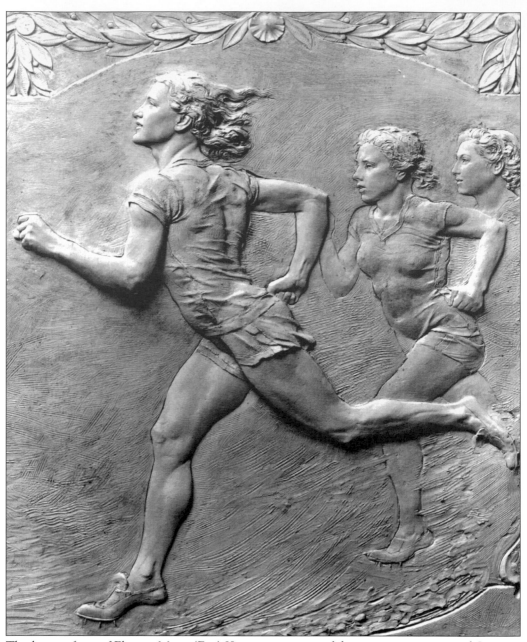

The bronze form of Eleanor Marie (Egg) Krattiger was one of the many commissions of Gaetano Federici, Paterson's unofficial "sculptor laureate" and the creator of numerous works of art in and around Paterson. His depiction of the girl known as Eleanor Egg was commissioned by the city in honor of its pioneer woman athlete and dance instructor. She competed in almost every track-and-field event open to women from 1923 to 1932, a career during which she collected 227 medals, 22 silver cups, and 6 statuettes. Egg set a world record in the broad jump in 1927. In 1931, she defeated Stella Walsh, the world record holder and favorite, in the 100-yard dash. Afterward, Egg was showered with gifts and testimonial dinners, leading to the commission of the Federici piece, which was displayed at Hinchliffe Stadium. (Courtesy of the Paterson Museum.)

The Italian-born Gaetano Federici's many sculptures included Count Pulaski, a 1929 work shown in two stages, as well as one—now outside St. John's Cathedral in Paterson—of an Irish priest, Dean William McNulty, comforting a barefoot orphan boy. Among his many other works was one commissioned by the family of noted silk ribbon manufacturer Julius Brandes. The seven-foot-long creation, completed in 1916 for placement at Paterson's Cedar Lawn Cemetery, is called the *Resting Pilgrim*. Federici died in 1964. (Courtesy of the Paterson Museum.)

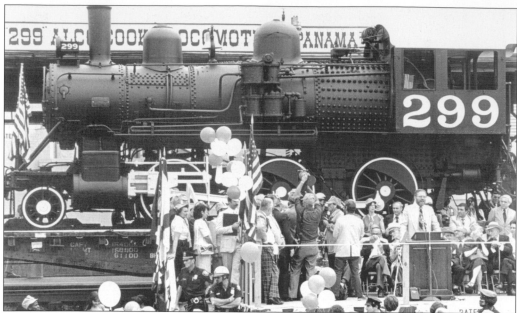

It was called "the Great Robbery," and it made front-page news in 1979. Engine No. 299, a 60-inch-gauge steam locomotive built in 1906 by the Cooke Locomotive Works of Paterson to help built the Panama Canal, was loaded aboard the freighter *Cristobal*. It was soon en route north after being moved from its perch in front of the Balboa train station, where it had been since 1955. Michael Pollak of the *Record* wrote, "Jesse James never did anything like this. Paterson Mayor Lawrence F. Kramer took a train—an engine and a coal car—out of Panama yesterday. He did it without paying a cent. He also created an international incident—the first heated dispute between the United States and Panama since the U.S. Senate ratified the treaty that will eventually give the Canal Zone back to the Panamanians." Today, the engine sits outside the Paterson Museum, where two famous Holland submarines, a silk warper, a Wright engine, and Colt revolvers can be seen up close by new generations of Americans. (Courtesy of the Paterson Museum.)

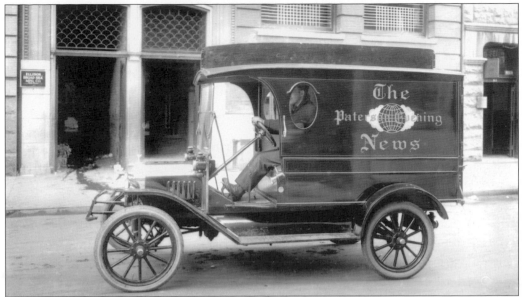

Looking for the latest scores in the major leagues was as easy as looking up, past this news truck, at the old Paterson Evening News Building on Ellison Street. The newspaper, founded by Edward B. Haines, produced several generations of reporters. Edward's son Harry B. Haines followed in his father's footsteps. "Among newspaper men and editors, Harry B. Haines of Paterson is regarded as a 'good fellow,' meaning that he is a congenial friend, bright of intellect, quick to see the funny side of every circumstance, cheerful and loyal to every trust," wrote the author of *Paterson and Its Environs*. The Haines family name later found itself on Overlook Park in recognition of its efforts to have the Great Falls declared a national historic site. In the early days, the News Printing Company not only published the *Evening News* but also picked up revenue as a bookbinder and printer, as can be seen this 1904 bill. (Courtesy of the Paterson Museum and the Richard Walter collection.)

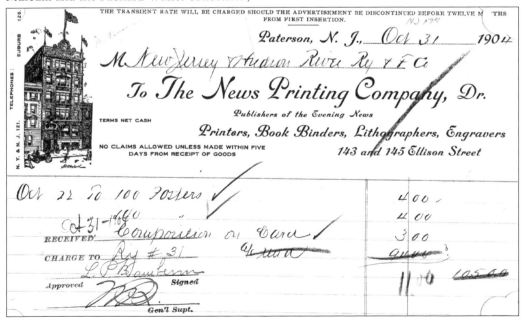

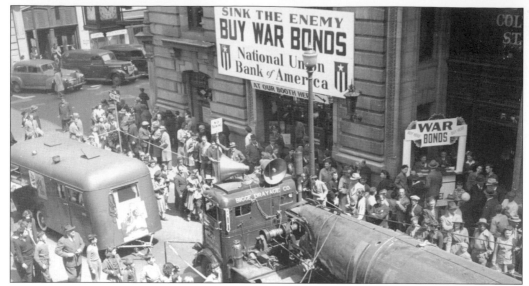

Abbott and Costello pitched bonds along with many Hollywood luminaries of the time. Dorothy Lamour alone was credited with selling $350 million worth of bonds by the close of the war. It was the World War II "bond blitz" to raise money for the war effort, and in the streets of Paterson (with a captured Japanese sub as the prop), the word went out to "Sink the Enemy" and "Buy War Bonds." As the war came to an end, more than $180 billion in bonds—carrying an interest rate of 1.8 percent—were sold. In 1945, flicking on the tube-powered radio, you would be able to hear Bing Crosby singing these words: "The enemy is reeling and his morale is low, So now's the time to fall in line and deal the final blow. Buy, buy, buy, buy a bond." (Courtesy of the Richard Walter collection.)

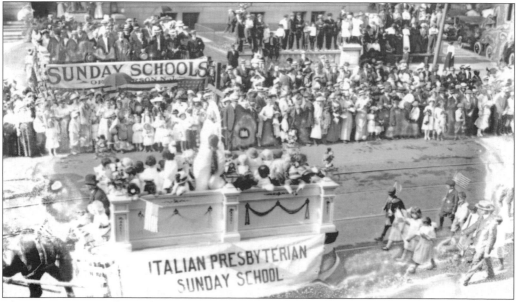

The Protestant Sunday School parade drew up to 10,000 marchers from some 50 churches on September 21, 1912. Rev. David Stuart Hamilton of St. Paul's Episcopal Church led 600 students of his own in the parade. In this updated picture, the horse-drawn float of the Italian Presbyterian Sunday School passes the reviewing stand. (Courtesy of the Paterson Museum.)

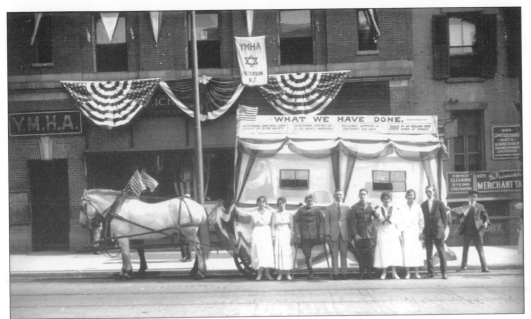

For "7,285 brave Paterson boys" in the service during World War I in 1918, such Paterson organizations such as the YWHA let it be known they had a part in the war effort. Mayor Amos H. Radcliffe penned a message to "Our Boys Over There," saying, "There is nothing greater I can wish to you than a speedy victory with a share in the glory and a safe return to your pursuits of peace at home. . . . Till then, 'good luck, over the top and give 'em hell." In the war's waning days, a front-page headline read, "Two Paterson Boys Fell in Final Action." One, Sgt. Walter Taylor of South Third Street, was wounded. Another, Pvt. Felix Ramatowski, was killed in the front-line trenches. For the hometown folks, there were wartime diversions. At the Majestic, there were the Big Keith vaudeville shows, whose 10 acts included "the Bullet Proof Lady" and "the Five Violin Misses." (Courtesy of the Paterson Museum.)

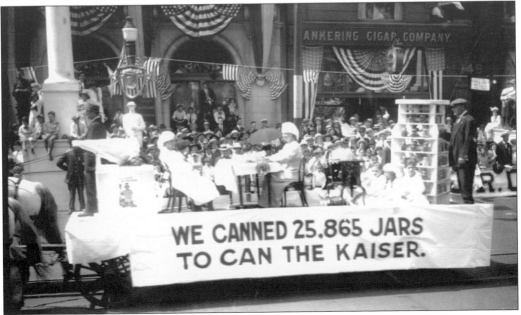

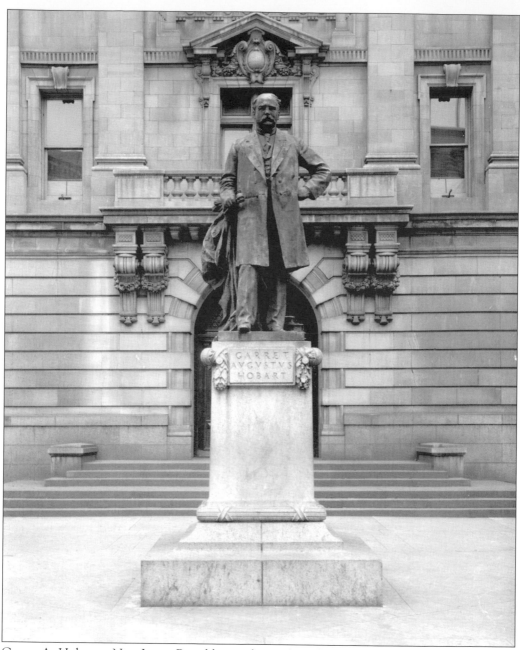

Garret A. Hobart, a New Jersey Republican who graduated from Rutgers College and ascended state GOP political circles, held the vice presidency under William McKinley from 1897 to 1899, when he died in office. Among other things, he cast the tie-breaking vote in the U.S. Senate against independence for the Philippines, which the United States unexpectedly acquired after the Spanish-American War. Several years prior, in 1896, the women of Vassar College penned this tune for the McKinley-Hobart ticket: "Hurrah for brave McKinley, For Garret Hobart true! A ballot that is cast for them, Is cast for freedom, too. Prosperity, Protection, We're going to vote them in. We'll carry the election, McKinley's going to win." (Courtesy of the Paterson Museum.)

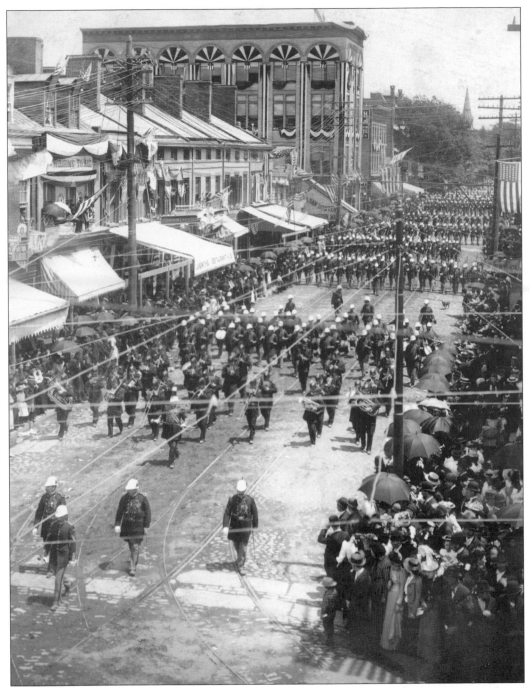

The Hobart funeral procession is shown as it makes its way through Paterson. At Hobart's death, President McKinley visited the Hobart house, saying, "No one outside of this home feels this loss more deeply than I do." McKinley himself was assassinated in 1901, an act that would have made "Gus" Hobart president had he lived. This series of events left open the political gates for Teddy Roosevelt. (Courtesy of the Paterson Museum.)

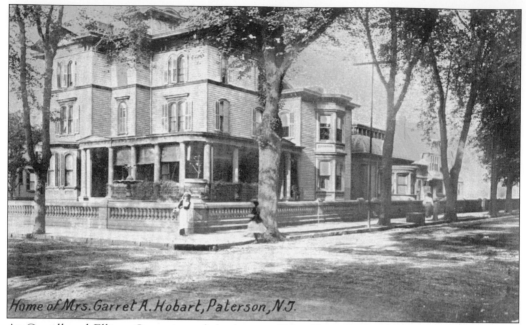

Home of Mrs. Garret A. Hobart, Paterson, N.J.

At Carroll and Ellison Streets stood the home of Vice Pres. Garret A. Hobart and, later, his widow. Carroll Hall (where the vice president's body had lain in state after his 1899 death) was eventually sold to the YWCA, and a Hobart mansion was built, one that eventually became the Paterson Teachers College, which purchased the estate in 1949.

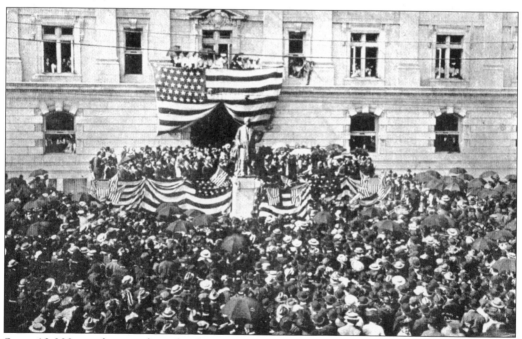

Some 10,000 people turned out for the unveiling of the Garret A. Hobart statute at the new city hall plaza on June 3, 1903. The bronze sculpture—whose pedestal and base reach more than 18 feet high—was designed by Philip Martini. (Courtesy of the Richard Walter collection.)

Four

WHISTLE STOPS

*Campaigning can become a state of mind, an end in
itself . . . limiting the office to those independently wealthy men
who can afford a costly campaign every two years.*

—U.S. Rep. Gordon Canfield urging colleagues in his 1960
farewell to Congress to embrace four-year terms
for members of the House of Representatives.

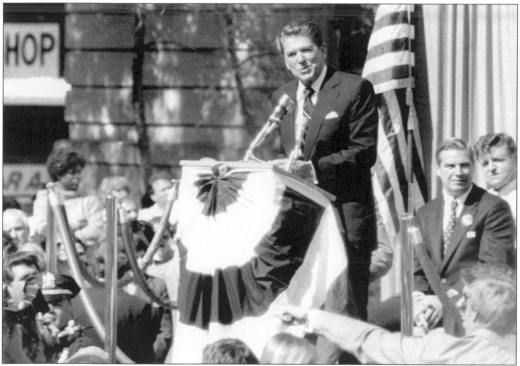

On October 1, 1980, presidential candidate Ronald Reagan came to Paterson City Hall, appearing before a crowd of up to 4,000 in a push for blue-collar votes. Then he uttered what the press called a "Bo-Bo," saying that Joseph "Bo" Sullivan (seated to the left of Sheriff Edwin Englehardt behind Reagan) would be the state's next governor. Trouble was, the millionaire Sullivan was one of eight GOP gubernatorial hopefuls in a field that included Paterson Mayor Lawrence Kramer. Reagan aides later dismissed the comment as "an absolute mistake." Kramer said of Reagan, "He thought there was one candidate." By Election Day, Reagan carried Passaic County, getting 82,697 votes to Pres. Jimmy Carter's 61,781. That same day, voters put the "blue laws" behind them, voting 64,176 to 46,062 to allow shopping on Sundays. (Courtesy of the Paterson Museum.)

81

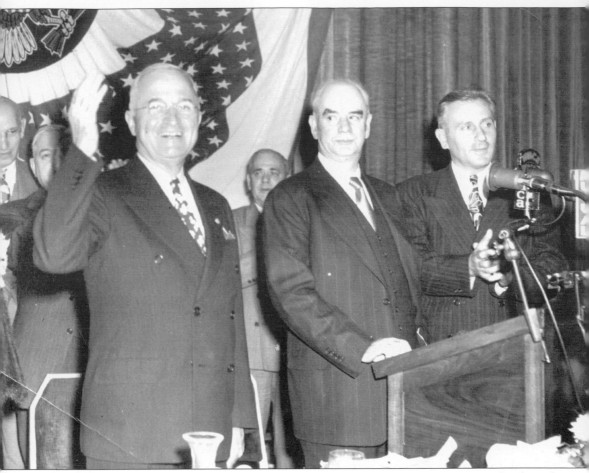

"Give 'em hell Harry!" was the cry Harry Truman evoked in a whistle-stop strategy that brought him to many towns across America. Truman had spent nearly fours years as an unelected president after Franklin D. Roosevelt's 1945 death in office. He saw the Congress fall to the Republicans in the midterm elections, and his popularity ratings fell as low as 36 percent. But Truman came out fighting, pushing a civil-rights platform and the nearly doubling of the minimum wage. He attacked the GOP Congress for not acting on his agenda and branded them "gluttons of privilege," saying the Republicans—whose ticket was now headed by Thomas Dewey—wanted to dismantle FDR's New Deal. The crowds responded with "Give 'em hell Harry." In the end, the election was perhaps best captured when a victorious Truman held up a *Chicago Tribune* bearing the off-the-mark headline "Dewey Defeats Truman." In the weeks leading up to the election, America had lost a baseball idol. Babe Ruth's funeral was held on August 19 at St. Patrick's Cathedral, and Ruth had lain in state at Yankee Stadium before the late-October burial near White Plains, New York. (Courtesy of the Paterson Museum.)

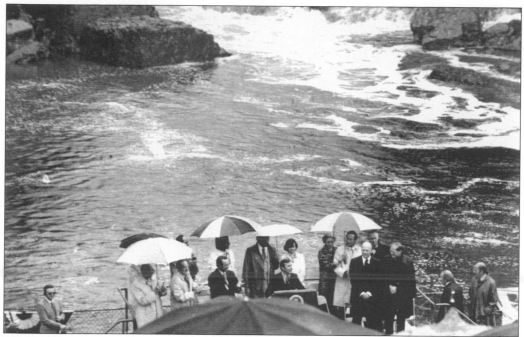

There was more than the spray of the Great Falls to deal with; there was a steady downpour. Yet, 60,000 turned out on June 6, 1976, as Pres. Gerald Ford came to designate the falls a national historic landmark. "If the people can stand in the rain for me, the least I can do is let them see me," Ford said to Mayor Lawrence F. "Pat" Kramer (shown at podium) after ordering his driver to open the top of the black presidential limousine. Along the motorcade route, the mayor got his shares of "Hi Pats" from the crowd, according to a *Paterson News* account of the day. The visit was just days from New Jersey's presidential primary. Come November, Ford would lose his bid for the White House to Democrat Jimmy Carter. Gov. Brendan Byrne (shown to Ford's left)—dubbed "one-term Byrne" by his opponents after the passage of the state's income tax—went on to be reelected. (Courtesy of the Paterson Museum.)

With the falls as a backdrop, Mayor Lawrence F. "Pat" Kramer pauses for a picture with another native son, Treasury Secretary William Simon. During Ford's 1976 stopover, Ford noted that Paterson was envisioned as an industrial center by the nation's first secretary of the Treasury, Alexander Hamilton. It was Simon who also served as "energy czar" during the 1974 oil embargo. In later life, Simon became a philanthropist. In 1998, some two years before his death, he announced his intention to give away his entire fortune. As a result, some $350 million was distributed to such charitable organizations as AIDS hospices and low-income educational groups. (Courtesy of the Paterson Museum.)

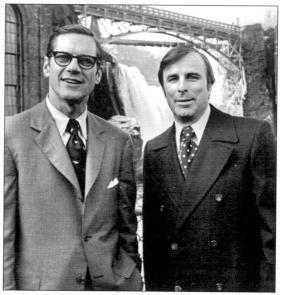

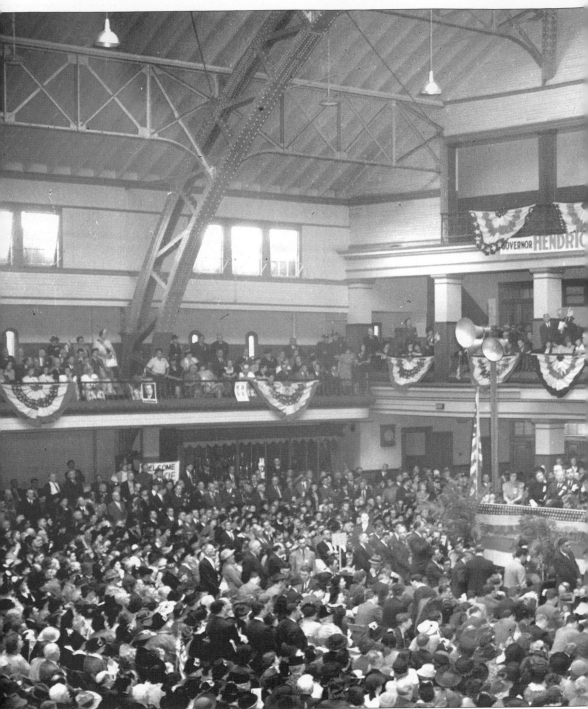

It was plugged as the first presidential stopover in Paterson since Herbert Hoover's in 1928. So when Wendell Willkie, the GOP presidential candidate opposing Franklin D. Roosevelt, came to the Armory on October 7, 1940, thousands showed up to hear the Willkie message. The New Deal, he said, would lead America to bankruptcy. By day's end in Newark, Willkie was hammering away at the Democratic "bosses," saying the president depended on "pigmy Hitlers"

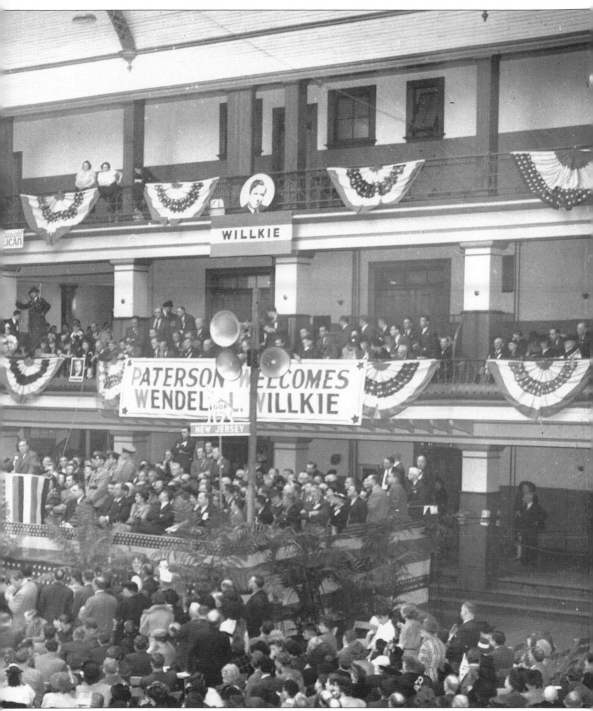

for votes. There were some sidelights to the Paterson visit; a wave of confetti rained down on the candidate in what observers likened to a World War I victory parade. But there was this observation from officials that day: "Not one autograph hunter asked Willkie for his signature." (Courtesy of the Passaic County Historical Society.)

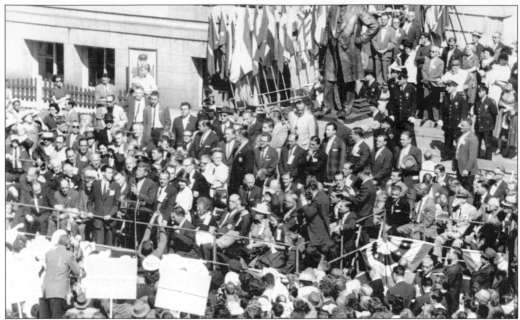

Sen. John F. Kennedy pressed the flesh in Paterson on a 1960 stopover in his run for the White House, drawing an estimated 15,000 onlookers. "Give us your voice, your help, your hand in this campaign, and we will win it," he said to what *Herald-News* reporter Arthur F. Lenehan described as "a mighty roar." It was shortly after noon on September 14, and Kennedy's motorcade—led by his white convertible—would head down Main Street, into Clifton and then Passaic. First, however, he took aim at the opposition. "The Republican Party has opposed every effort we have made in this century to better the welfare of our people," Kennedy said. "I think that it is time that this country started to move again." In some added excitement, two prisoners took advantage of the visit to slide down a coal chute, escaping from police headquarters. One of the prisoners, who had been accused of disorderly conduct and motor-vehicle charges, was quickly caught after detectives fired shots over the heads of Kennedy onlookers. The second escapee was successful in getting away. (Courtesy of the Paterson Museum.)

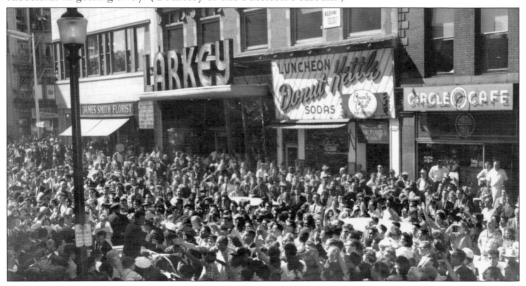

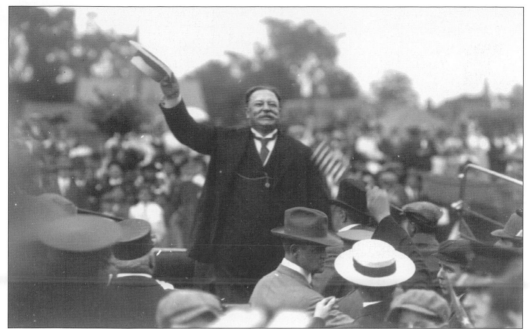

Tapped by Teddy Roosevelt as his successor, William Howard Taft did not take to campaigning, describing the task as "one of the most uncomfortable four months of my life." Yet Taft's election in 1908 was believed to appease more than one camp. "Roosevelt has cut enough hay," progressives were quoted as saying of the departing incumbent. "Taft is the man to put it in the barn." As far as the conservatives were concerned, they were said to be happy, rid of the "mad messiah." Yet, when Republicans renominated Taft in 1912, progressives had already felt slighted by his administration, and Roosevelt bolted from the party to lead the Progressives, making for three-way split that put Woodrow Wilson in the White House. Here, Taft is looking jovial as ever on a campaign swing in Paterson. (Courtesy of the Paterson Museum.)

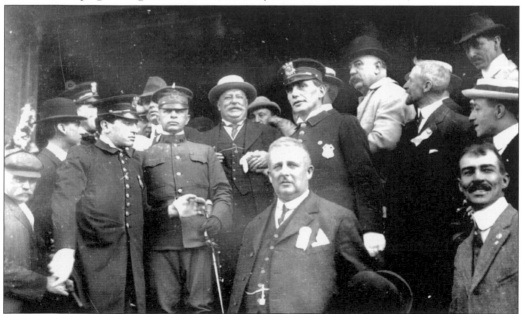

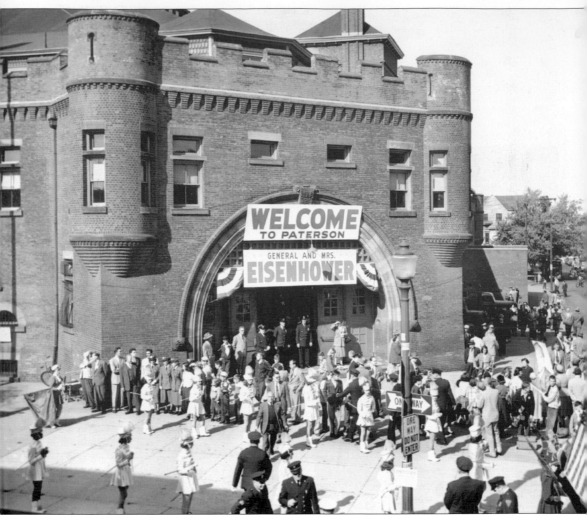

The "Welcome to Paterson" banner greeted Gen. Dwight David Eisenhower outside the Armory on October 16, 1952. This *Paterson Evening News* photograph was taken during Eisenhower's first run for the White House. He was in the political seat of Passaic County, which in 1948 went for Harry Truman by 572 votes. The Armory was packed, but those in attendance were well entertained. Bandleader Fred Waring flew in from Pennsylvania; Al Lawrence, organist at Gene Boyle's restaurant in Clifton, played the accompaniments; and Joseph Durgett led the band. According to news reports of the day, only one Adlai Stevenson banner was evident. (Courtesy of the Paterson Museum.)

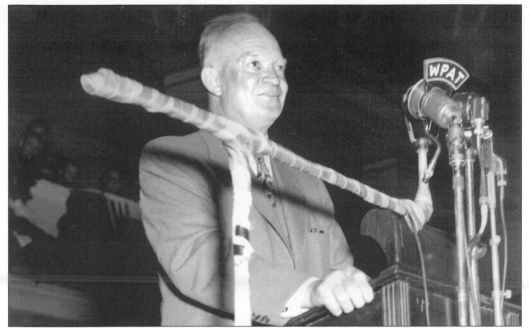

Ike takes to the mike, and Paterson's WPAT radio was there during the 1952 stopover. The dignitaries included Governor Driscoll and Herman G. Schulting, whose GOP organization forces reportedly distributed 6,000 U.S. flags for the crowds to wave along the motorcade's route. For those seeking escape from the pressing issues of the day, there was always something showing at the movies in Paterson. At the Garden, there was *Back at the Front*; at the Fabian, the *Quiet Man*; and at the Regent, *Brute Force* and *Street with No Name*. For the true escapists, there was always the matinee at the Rivoli, which was showing *The Hunchback of Notre Dame* and *The Cat People*. (Courtesy of the Paterson Museum.)

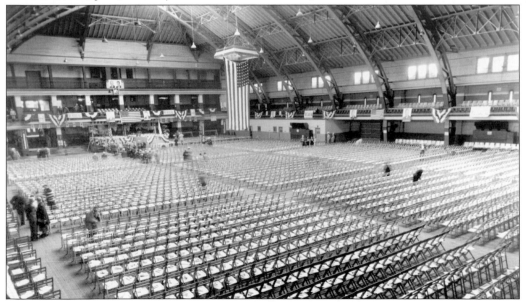

It was quite a task to set up thousands of folding chairs for Eisenhower's 1952 visit, but with 75,000 square feet under one roof, the Armory had no shortage of space.

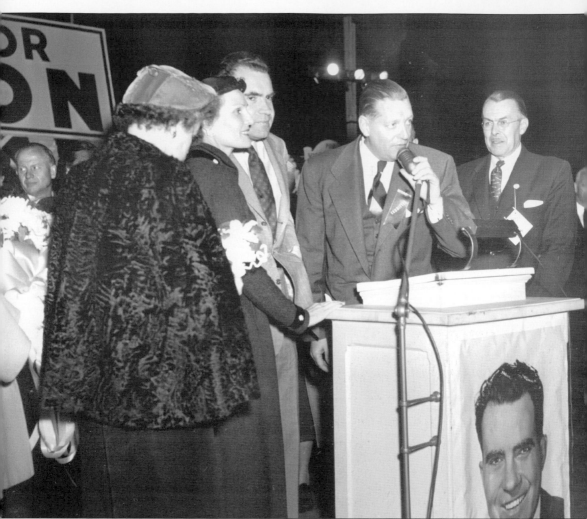

Also on hand during the 1952 whistle stop was Eisenhower's vice presidential running mate, Richard M. Nixon, and his wife, Pat. It was Nixon who would face a young Massachusetts senator named John F. Kennedy in 1960, losing in a tight election and signaling the start of a short-lived era of Camelot in Washington. Nixon was elected president in 1968 and was reelected in 1972, only to end up resigning in the midst of the Watergate scandal.

Five

THAT'S ENTERTAINMENT

I never should have left Paterson.

—Lou Costello in *Abbott and Costello Meet the Invisible Man.*

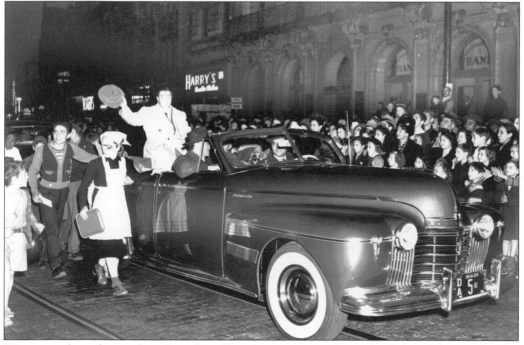

Waving to his adoring fans, Lou Costello takes a motorcade to the Fabian Theater for the premiere of the 1940 film *One Night in the Tropics*. Never one to forget his friends, Costello once asked Paterson's town fathers to give his old friend and one-time athlete John "Midge" Shields a six-week leave of absence from his job as a refuse-truck driver so he could spend the time with Costello at his Van Nuys, California, home. "For six golden weeks, he visited every well-known place in Hollywood and was introduced to the celebrities on every movie location," wrote Fr. Anselm Krieger in an article in the Franciscan newspaper *Friar.* (Courtesy of the Passaic County Historical Society, Zito collection.)

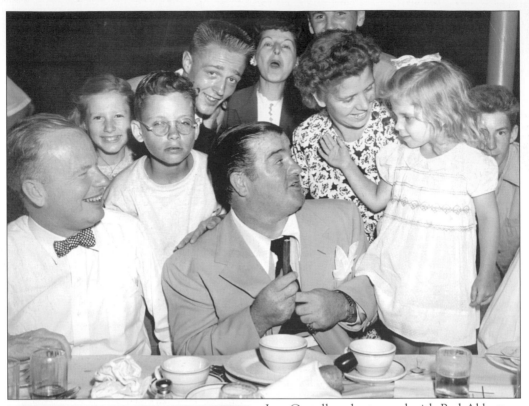

Lou Costello, who teamed with Bud Abbott to create one of Hollywood's all-time great comedy duos, never missed a chance to invoke the name of his hometown, as he did when he said, "I never should have left Paterson" in *Abbott and Costello Meet the Invisible Man*. There were other reminders. In *The Naughty Nineties* (1945), the classic "Who's on First" scene is performed in front of a painted backdrop depicting a baseball game with the words Paterson Silk Stockings plainly visible. Costello, born Louis Francis Cristillo at 14 Madison Street, frequently returned to Paterson for screenings of his films, as he did for *One Night in the Tropics* (1940) and *Jack and the Beanstalk* (1952) at the Fabian. On one of his return visits, he took some time out with schoolchildren and Rep. Gordon Canfield, as well as with Abbott at the 1949 Golden Gloves at Hinchliffe Stadium, a moment captured by the *Paterson Evening News*. Today, admirers can visit the Abbott and Costello Fan Club on the Internet or the life-size bronze statue called *Lou's on First* at Cianci and Ellison Streets. (Courtesy of the Paterson Museum and the Richard Walter collection.)

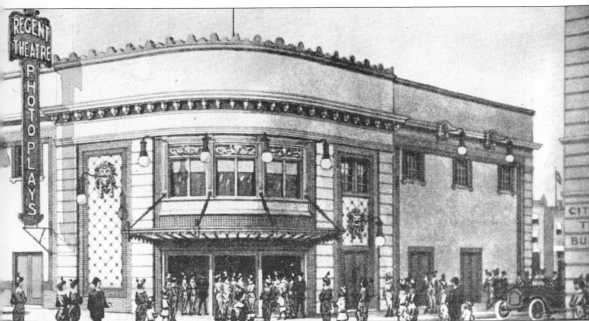

The Regent was so expensive to build at the time, it was known as Fabian's Folly, after Jacob Fabian, who officially opened Passaic County's first theater dedicated to motion pictures on September 14, 1914. Paterson's own Fred Wentworth was the architect of the 2,400-seat picture palace, at old Union (now Veterans Place) and Hamilton Streets. But the Regent's influence was catching. The next year, Max Gold built the Garden Theater, soon selling it to Fabian. In 1923, Fabian leased H.B. Kitay's Rivoli Theater. Then, just two years later—and with "talkies" about to debut—he erected the Fabian Theater on Church Street. The Regent fell victim to the wrecker's ball in favor of a parking lot in 1956, but not before seeing the likes of Bob Hope, Jack Benny, Milton Berle, and in his first performance in the East, Cab Calloway. "Memories still persist of organist Warren Yates," said E.A. Smyk, Passaic County historian, in a 1992 "Tales of Our Heritage" column, "as well as machines attached to back seats which dispensed candy for pennies." (Courtesy of the Richard Walter collection.)

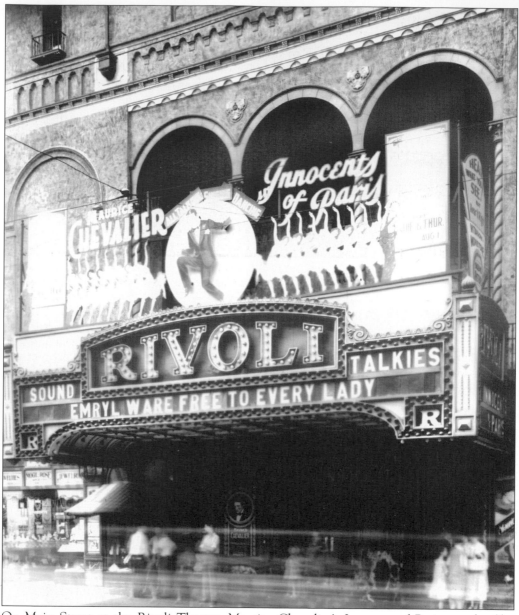

On Main Street at the Rivoli Theater, Maurice Chevalier's *Innocents of Paris* was the film feature. It was the French star's first Hollywood musical, coming just two years after Al Jolson's *The Jazz Singer*, the first all-talking picture. In the 1929 film, Chevalier sang "Louise," one of his signature songs. It ended with this refrain: "Anyone can see why I wanted your kiss, It had to be. But the wonder is this: Can it be true, Someone like you, Could love me Louise." In the 1950s, Chevalier would star in the Oscar-winning musical *Gigi*. His last work was the title song in the 1970 Disney movie *The Aristocats*. (Courtesy of the Paterson Museum.)

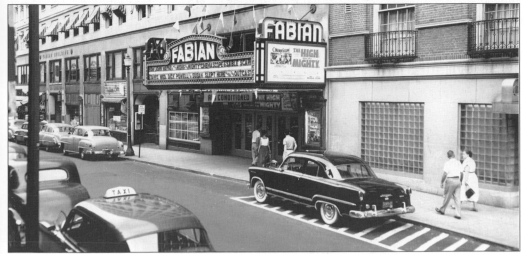

"New Theater Will Be Beauty Palace," read the headline in the *Paterson Press-Guardian* on December 17, 1921, after Jacob Fabian unveiled plans for the 3,000-seat theater that would bear his name next to the Alexander Hamilton Hotel on Church Street. The fan-shaped auditorium, the article said, would have "1,800 seats upholstered in Spanish leather 2 inches further apart than the law requires and considerably further apart than those at the Regent." This would give patrons "a maximum amount of comfort, rest and ease." There would also be special floor boxes "furnished with massive, costly furniture." Years later, when this picture was taken by *Morning Call* staff photographer Russell Zito in August 1954, *The High and the Mighty*, an airplane-disaster film starring John Wayne, was playing. The film, competing against the year's heavy favorite, *On the Waterfront*, was nominated for six academy awards but captured just one, for best score. (Courtesy of the Passaic County Historical Society.)

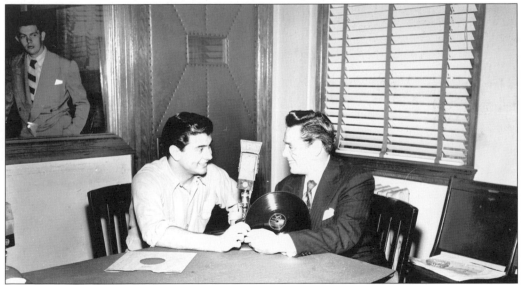

On a Paterson stopover, Desi Arnez sat down for a radio interview at WPAT in September 1947, some seven years after he married Lucille Ball. Arnez, born in Cuba, fled to the United States at the age of 16 with his mother. In the 1930s, he had his own rumba band and, in 1940, hit the screen in *Too Many Girls*. The biggest success was yet to come—the long-running television show *I Love Lucy*. (Courtesy of the Passaic County Historical Society, Zito collection.)

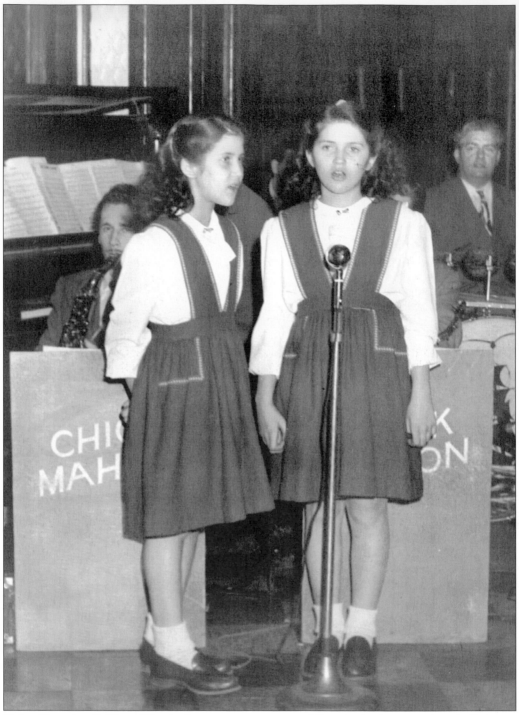

Twins Georgina (left) and Bessie Auger sang at many weddings and other occasions in Paterson in the 1940s. At the age of 10 in 1945, they performed here with bandleader Chick Mahon. Bessie now makes her home in Illinois. (Courtesy of Bess Holm.)

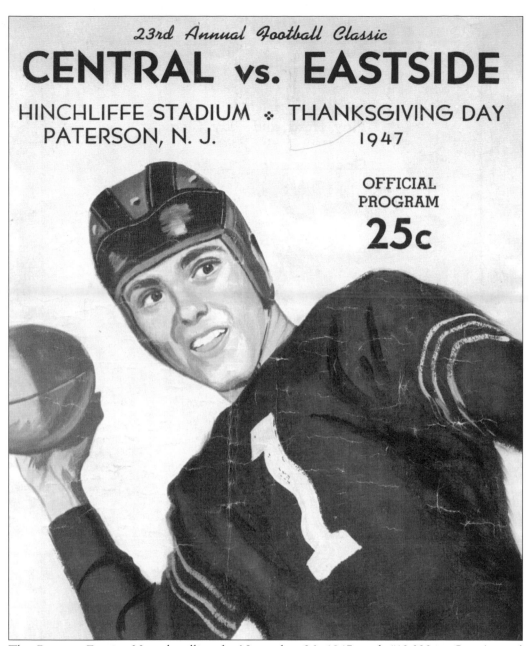

23rd Annual Football Classic

CENTRAL vs. EASTSIDE

HINCHLIFFE STADIUM ❖ THANKSGIVING DAY
PATERSON, N. J. 1947

**OFFICIAL
PROGRAM**

25c

The *Paterson Evening News* headline for November 26, 1947 read, "12,000 to See Annual Football Tilt Between City's Scholastic Squads at Hinchliffe Stadium." It was to be the 23rd football classic between the two schools, with each team having 10 wins and there being 2 ties over the previous 22 years. Going into the 23rd match-up, the teams' regular seasons were less than stellar. Eastside High's Ghosts—dubbed "the Undertakers" in the press—were the favorite. The next day told it all: "'Undertakers' Crush Colts for 11-10 Edge in Annual Series and Possession of News' Title Cup." Eastside blanked Central 25-0. The excitement was evident. "A mob of over-enthusiastic students swarmed onto the field," the newspaper reported, "and brought down both goalposts with more than 10 minutes left to play in the game." Both teams got a breather as the field was cleared.

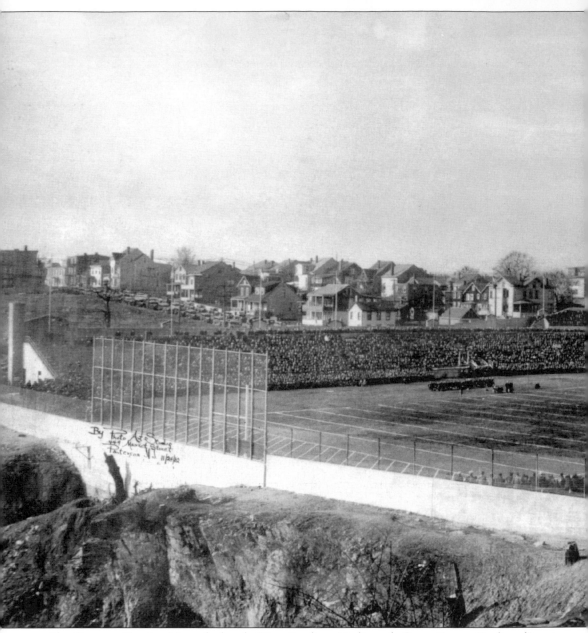

The *Paterson Evening News* declared, "New Stadium Dedicated; Great Future Predicted" as it discussed the dedication of September 18, 1932. It was called Hinchliffe City Stadium, named in memory of Mayor John Hinchliffe, the uncle of the then-current mayor, John V. Hinchliffe, as well as John V. himself. One of the day's highlights was the presentation of the Eleanor Egg plaque, named for the star Paterson athlete who the year before won the national championships in the 100-yard dash. "It is possible that there have been times when over-emphasis has been

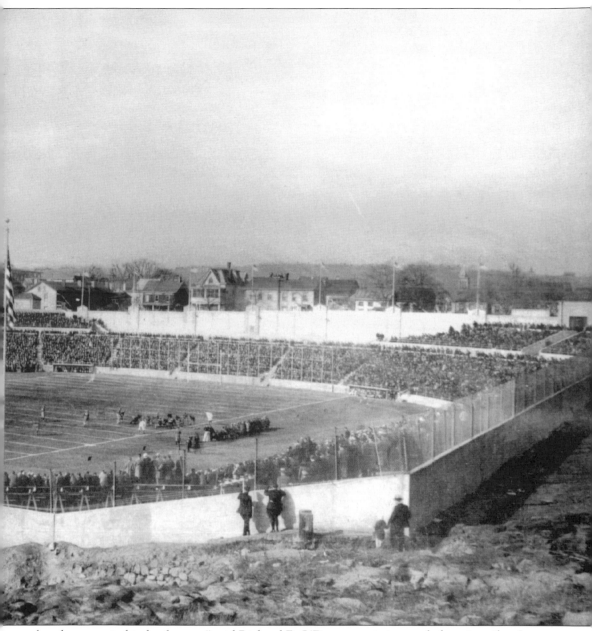

placed on certain kinds of sports," said Richard E. O'Dea, commissioner of education, "but I am certain that there cannot be too much emphasis placed upon the healthy, honest, womanly type of athletics that Eleanor Egg represents." Soon, Mary Hinchliffe, the mayor's daughter, would raise the standard over the field. The stadium would serve Paterson well, for annual high-school rivalries and midget car racing. (Courtesy of the Paterson Museum.)

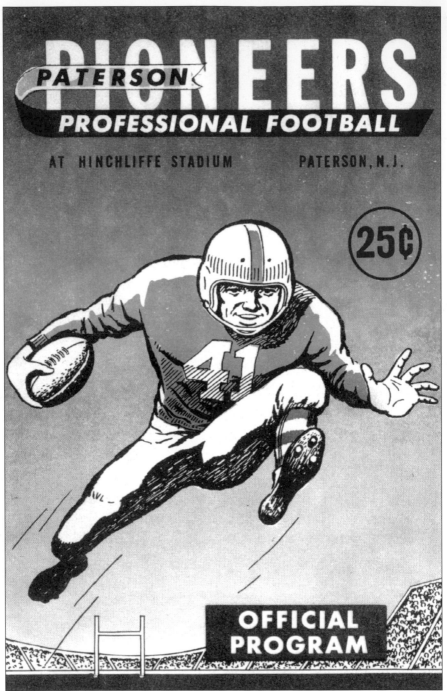

Loaded with stats on the players as well as the schedule for the 1960 season, the 25¢ program of the Paterson Pioneers of the Eastern Football Conference told of its origins at the hands of general manager William Caruso: "But the team's roots go back to the Paterson Panthers of 10 years ago—the great team whose history and record inspired Bill Caruso to build the new professional team in the same tradition." The home games at Hinchliffe Stadium included bouts with Plainfield, Franklin, the Generals, and Mount Vernon. (Courtesy of Glory Read.)

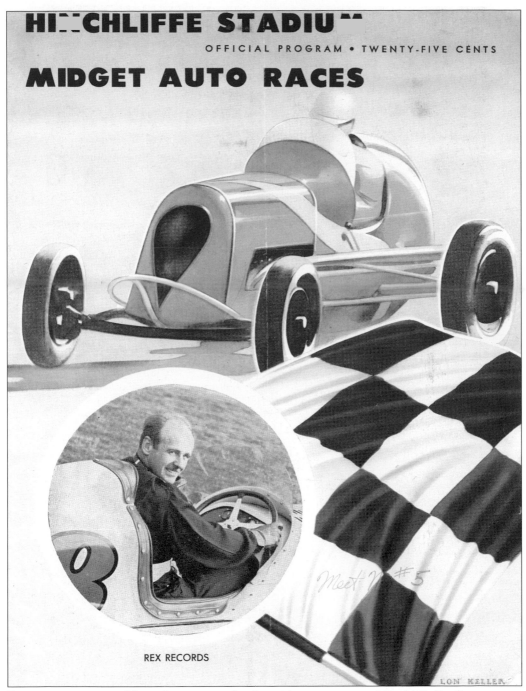

For a quarter, you could get the program for the midget car races at Hinchliffe Stadium.

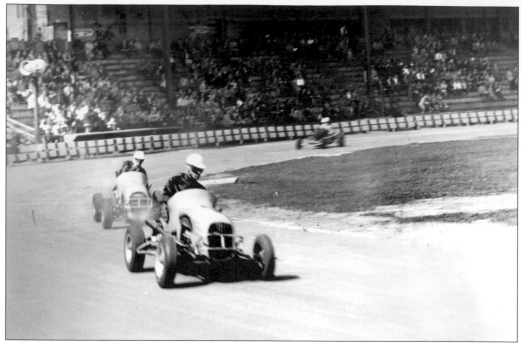

"Gasoline Alley: Paterson's Center for Speed" was one of the many exhibits featured at the Paterson Museum. There, visitors could step back to days when midget cars built at the Alley—a row of garages between Seventeenth and Eighteenth Avenues—would hit the track at Hinchliffe Stadium, where the races ran from 1939 to 1950. Stock car racing continued until 1952, when neighbors on adjoining streets let it be known that they could no longer stand the noise. (Courtesy of the Paterson Museum and the William Nash collection.)

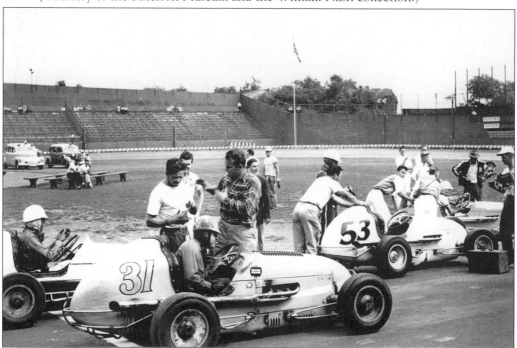

Six

THE PATERSON LOUVRE

*The importance of this gift and its far-reaching effect on the cultural future
of Paterson cannot be overestimated. What the lovely and gifted Vittoria
Colonna was to the Renaissance, Mrs. Hobart will be to Paterson.*

—James Gabelle, *Morning Call* reporter on occasion
of 1925 unveiling of the Hobart collection.

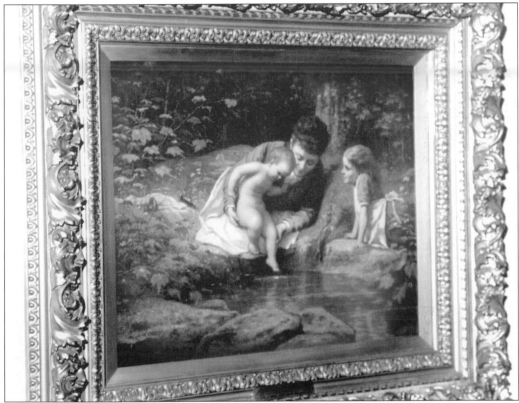

It was a legacy from Jennie Tuttle Hobart, who in 1925 as a memorial to her husband, Vice Pres. Garret Hobart, donated a handsome art collection that to this day hangs in what could be called Paterson's Louvre. The page-one headline that day read, "Hobart Collection Thrown Open to Public Today, Gift is of Far-Reaching Importance to the Cultural Life of Our City." The collection included 26 works of art. Among those now on permanent display at the library is the 1872 painting *The Bath*, by Eastman Johnson, described as "one of the most important American painters of the 19th Century." At the time of the Civil War, Johnson (1824–1906) began a series of genre paintings depicting life in the South, the most famous of which was *Old Kentucky Home*, an 1859 work that revealed the sharp contrast of slave quarters with the homes of the plantation owners. Other works include a portrait of a gavel-holding Hobart, presented to Mrs. Hobart by members of the New Jersey State Assembly, where he was speaker in 1874. (Courtesy of the Danforth Library.)

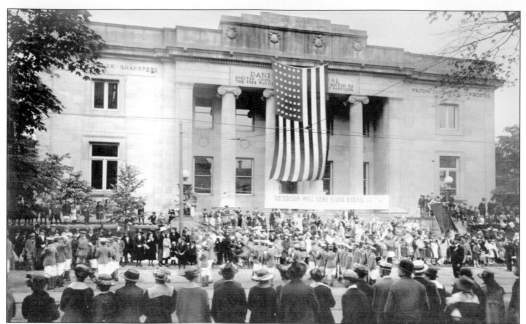

Opened in 1905, the Danforth Memorial Library is a work of art in itself, one designed by Henry Bacon, architect of the Lincoln Memorial. Today, Bacon's original drawings are housed there, but Bacon had other handiwork in Paterson: the Memorial Day Nursery and Vice Pres. Garret Hobart's neoclassical mausoleum at Cedar Lawn Cemetery. During World War I, however, a banner read, "Paterson will send 15,000 books," in this case to American doughboys. The image, by noted photographer John Reid, is of the Danforth Library on Broadway. Inside, well-dressed children pursue the magic of reading. (Courtesy of the Paterson Museum.)

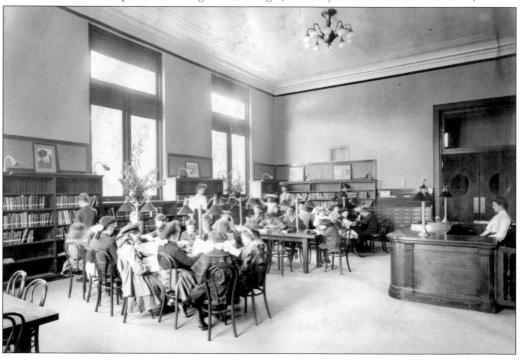

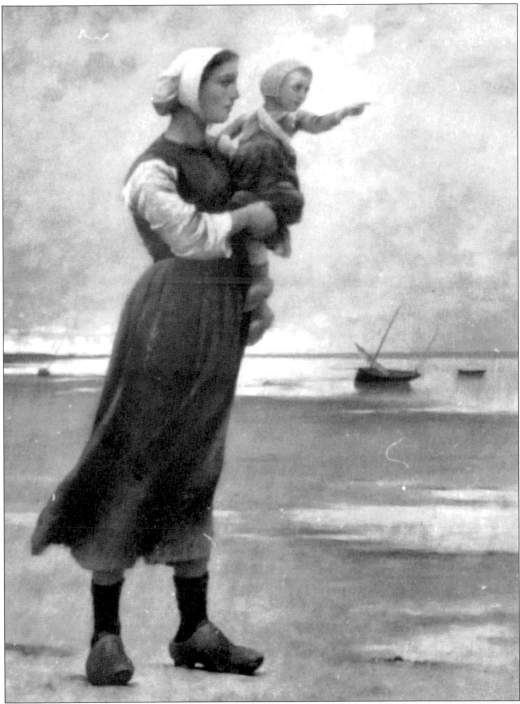

Also on view at the library is V.N.A. Hagborg's *Waiting for Papa*. The work of the artist, who lived from 1852 to 1921, is described this way in a press report of the day: "A fisherman's wife with their child in her hands stands upon the sandy beach from which the tide has retreated, leaving shallow pools and scattered shells as a memorial of its presence. . . . The child is pointing eagerly in the direction of the father's boat." (Courtesy of the Danforth Library.)

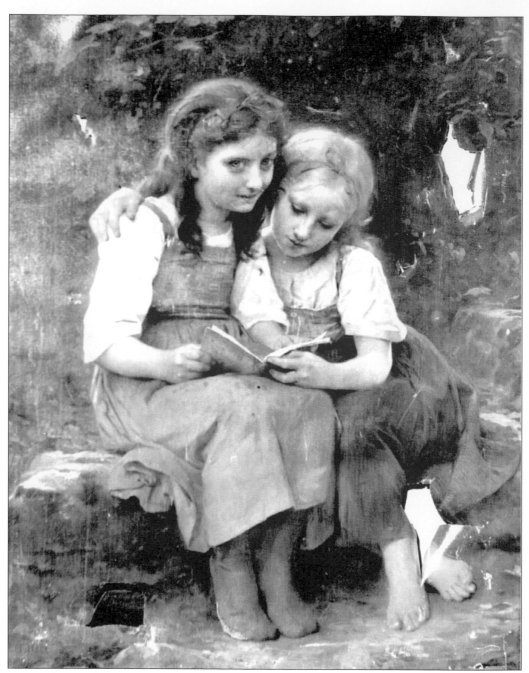

Restored since this photograph was taken, *Two Little Girls* is part of the Hobart Collection. The painting is the 1887 work of Leon Perrault, born to a very poor family in France in 1832. Critics were impressed with the honesty of his genre paintings, whose subjects are typically children with eyes that reveal innocence and warmth but also show a youthful maturity reflective of his own childhood in poverty. Among the library's other works are those donated by Ralph Ross, one of the city's leading philanthropists, and those of the Underground Railroad Portrait Project, which includes the 1874 Thomas Waterman Wood painting of Paterson abolitionist Josiah P. Huntoon. (Courtesy of the Danforth Library.)

HALLOWED HALLS

All good fortune to the brave,
Every blessing to the true
And we live long past the grave
Through everything we say and do.

You've passed the torch
We'll carry it high
Ever a beacon—ne'er to die.
That our nation under God
May ever prosper and grow strong.

Through the years when we were gone,
Your ideals shall lead us on.
Virtues which your life gave proof,
May we hold as truth.

—"The Torch," Kennedy High alma mater,
music by David Palmier,
lyrics by Rev. James Murray,
Cathedral of St. John the Baptist.

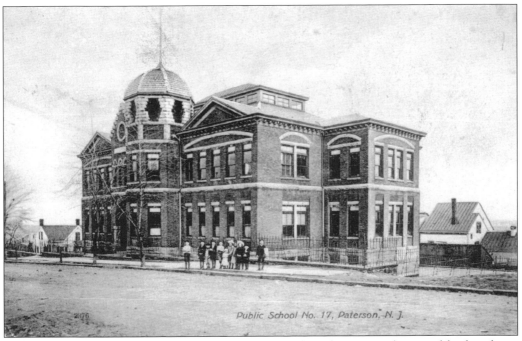

Public School No. 17, Paterson, N. J.

Paterson's School No. 17 was built in 1891, a time when the surrounding neighborhood was populated by those of Dutch and German ancestry.

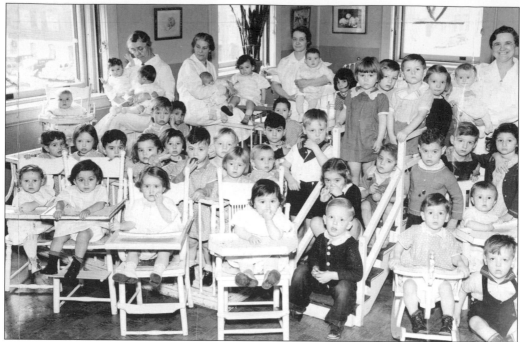

Despite a huge influx of immigrant families, Paterson's many industries still faced a severe labor shortage, leading more women—and mothers—to work in the mills. The Memorial Day Nursery—known as the "nickel house" to reflect its daily charge—was the answer of the women married to wealthy mill owners as well as Jennie Hobart, the widow of the vice president. The white brick building at Grand and Hamilton Streets was endowed in the memory of her 17-year-old daughter, Fannie Beckwith Hobart, who died while vacationing with her family in Europe in 1895. Today, their portraits hang in the formal entry hall of the nursery.

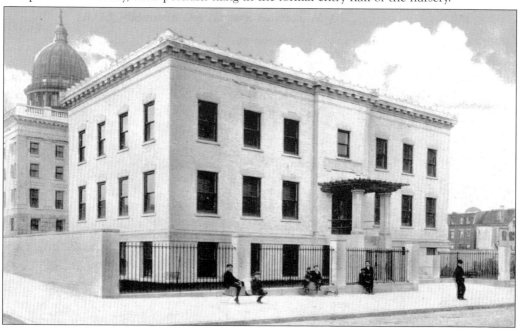

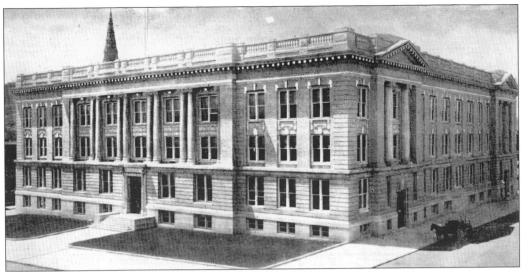

Special praises were said in the memory of Elizabeth Kelley, a teacher who was instrumental in raising funds for the school's pipe organ. "Thousands Attend Dedication of the New High School," read a headline on June 23, 1911, a day after the dedication of old Central High School. Mayor Andrew McBride, according to a report in the *Paterson Morning Call*, had a special message: "Mayor McBride . . . dwelt on the sacrifices that the parents of the school pupils had to endure," the reporter wrote, "and of the great burdens they were forced to bear. He told the boys and girls the school was theirs, admonishing them to never do anything that would make their school ashamed of them." Fast-forward 54 years to the day, and an era ended at Central. The Class of 1965 was the last for the school, atop what was once known as Colt Hill. Starting in September of that year, all would be going to a new $7 million John F. Kennedy High School built in Westside Park. (Courtesy of the Paterson Museum.)

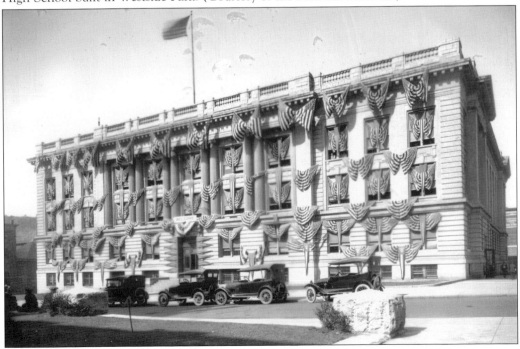

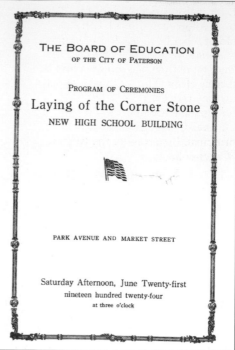

PATERSON'S NEW HIGH SCHOOL IS THE GREATEST AND COST-LIEST PUBLIC BUILDING EVER UNDERTAKEN IN THE 133 YEARS OF THE CITY'S HISTORY. THE SITE COMPRISES ABOUT SEVEN ACRES IN THE HEART OF THE RESIDENTIAL SECTION. THE SCHOOL ITSELF WILL CONSIST OF SIXTY-THREE CLASS ROOMS, A LARGE AUDITORIUM WITH A SEATING CAPACITY OF 2,000, TWO LARGE GYMNASIUMS, ROOMS FOR MANUAL AND HOUSEHOLD ARTS, LIBRARY, ETC.

THE COST EQUIPPED WILL BE NEARLY $1,500,000, AND WHEN FINISHED WILL STAND AS A LASTING MONUMENT TO THE PROGRESSIVE SPIRIT OF PATERSON IN HER IDEALS FOR THE "EQUALITY OF OPPORTUNITY" FOR HER FUTURE CITIZENS.

THE BOARD OF EDUCATION
OF THE CITY OF PATERSON

PROGRAM OF CEREMONIES
Laying of the Corner Stone
NEW HIGH SCHOOL BUILDING

PARK AVENUE AND MARKET STREET

Saturday Afternoon, June Twenty-first
nineteen hundred twenty-four
at three o'clock

Paterson honored one of its favorite sons at the cornerstone laying ushering in the new high school at Park Avenue and Market Street in 1924. His name was Nicholas Murray Butler, then president of Columbia University. A parade started at 210 Main Street, stopped for the laying of the cornerstone, and proceeded to Sandy Hill Park, where 500 students performed "callisthenic exercises" and heard an invocation by Rev. David Hamilton of St. Paul's Episcopal Church. A chorus of 400 boys and girls then sang Wagner's "The Pilgrim's Chorus." (Courtesy of the Richard Walter collection.)

Built in 1886, School No. 14 (on Union Avenue) is Paterson's oldest school still in use. In its first academic year (1887–1888), there were more than 300 children and a faculty of six. The teachers' annual income was $375 each. The first-grade teacher, S.E.W. Olmstead, filled in as acting principal. (Courtesy of the Richard Walter collection.)

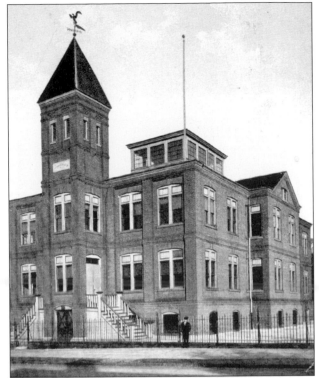

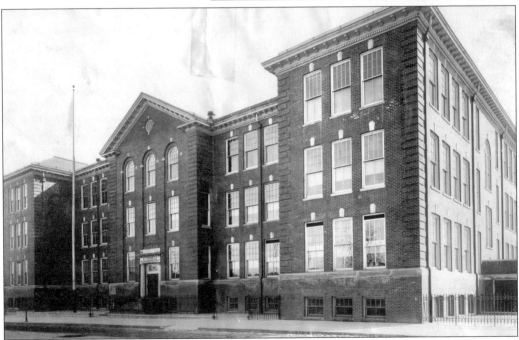

It was first called the Weaverton School when the cornerstone was laid in 1905. Then, what is now known as School No. 21 had 16 classrooms, with 14 more destined to be added in 1918. Its first class, in 1908, had 36 graduates, all instructed by teachers with an annual salary of $425. In 2001, 10 more classrooms were added.

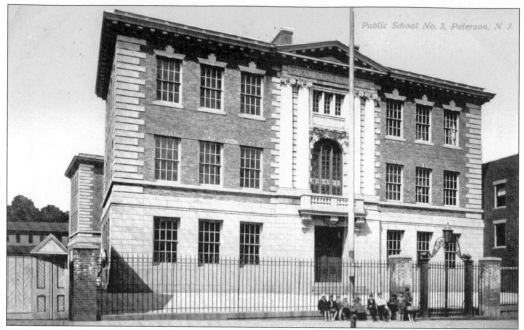

School No. 3 (above) had its beginnings more than 100 years ago, as did School No. 20, constructed in 1896, with additions in 1926 and 2000. It was the time of that second addition when enrollment was on an upswing. "Many new pupils in two high schools. . . . Italian classes being organized for the first time," read a newspaper headline. It was the first time such a class was offered at Central High School, drawing 28 students.

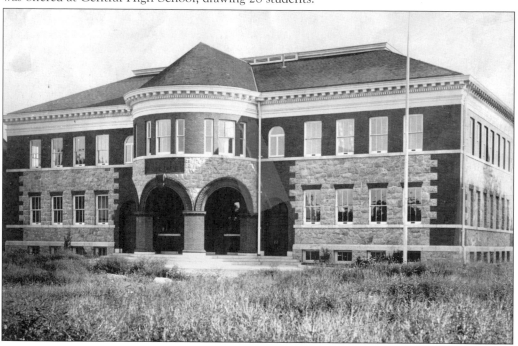

Eight

THE "UPPER" EASTSIDE

*We roller skated in the middle of the street, rode our bikes, walked
everywhere. . . . Paterson was a really, really neat town. So much of Paterson is still
standing. . . . I go back a lot for someone who lives in Maryland.*

—Janet Michelson Read, who grew up on
East Twenty-fourth Street and went on to graduate
10th in her class at Eastside High School in 1956.

White dresses were the uniform of the day in the early 1920s in Eastside Park. Today, among
the many park attractions are a Gaetano Federici statue of Christopher Columbus, erected in
2000, and a statue erected in 2002 of Paterson's own Hall of Famer, Larry Doby, overlooking a
baseball diamond named in his honor.

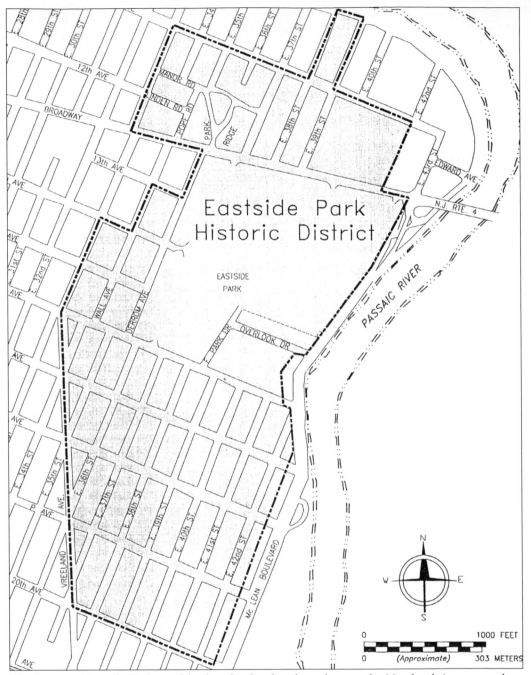

The historic Eastside Park neighborhood is bordered on the west by Vreeland Avenue and on the east by McLean Boulevard.

The grass apron along Broadway at Thirty-ninth Street sported all kinds of elaborate flower arrangements, such as "Welcome to Paterson" and even "Buy War Bonds." These plantings were created by three generations of McCrowes. It was the British-born Henry McCrowe who was tapped to create parks when Paterson had none in 1894, starting development of Eastside Park. Next, his son Robert took over, supervising creation of Sandy Hill and other parks, and then Robert Jr., who joined the park system in 1935, eventually becoming superintendent. In 1958, McCrowe made his last, a V for victory, which he said remained popular even though the war was long over. (Courtesy of the Richard Walter collection.)

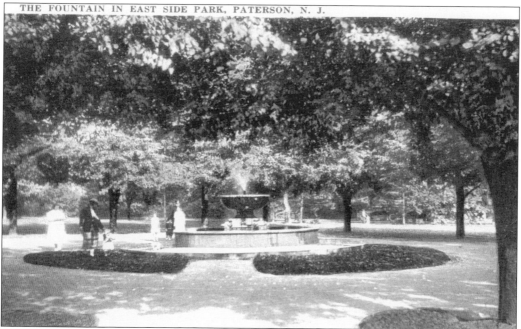

Shown in a vintage 1923 postcard, the Alice B. Wright Fountain has since been restored by the Eastside Park Neighborhood Association.

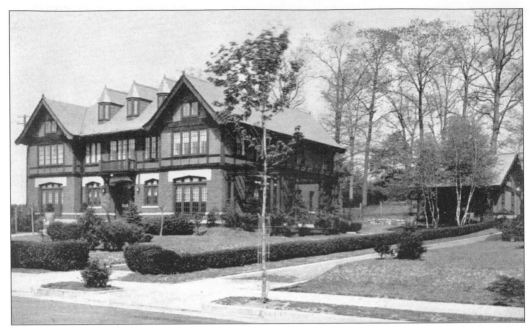

His name was Andrew Derrom, a man who, as a colonel in the Civil War, would lead five companies of Paterson men into battle against the Confederates at Fredericksburg, Virginia. In civilian life, he was Paterson's first superintendent of schools and the first president of the school board. Around 1870, he purchased much of present-day Eastside, whose park was once home to his Mount Elizabeth estate. In the ensuing years, one of Eastside's prettiest streets would bear the Derrom name. In a *Paterson Guardian* publication from 1923, the estate above, at 139 Derrom Avenue, was identified as the home of Walter Bamford. The one below, at 167 Derrom, was the home of J.J. Diskon.

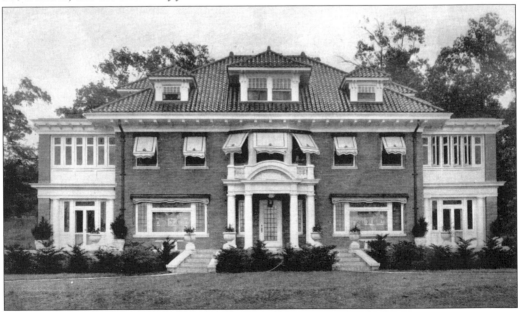

McCRAN MEMORIAL - EASTSIDE PARK, PATERSON, N.J.

With seating to accommodate 80 people (40 on each side), the McCran Memorial in Eastside Park was dedicated in 1927 in honor of Attorney General Thomas F. McCran, who lived nearby and was said to frequent the park in an area overlooking the Passaic River from the highest terrace. "The memorial, when completed, will be a beautiful acquisition to Eastside Park and one of the finest memorials of its type in the country," said a news story in the *Paterson Morning Call*. (Courtesy of the Richard Walter collection.)

There was no need for a day at the zoo, given the animals at Eastside Park in this postcard scene. Things were not always idyllic, however. Eastside, fashionable as it was, had some unwanted visitors shortly before the dawn of the 1920s. "Beware of This Bedroom Thief," read the headline on a page-one newspaper story. The burglar always entered via a bedroom window, in the latest incident striking an East Twenty-fourth Street home.

All wrapped up for the holidays, this home on Park Avenue was originally a wedding gift for one of the Konner family daughters in 1941. Just around the corner is another home, built as a wedding present for her sister. The illustration is by Gil Riou. (Below, courtesy of Lauren Ann Read.)

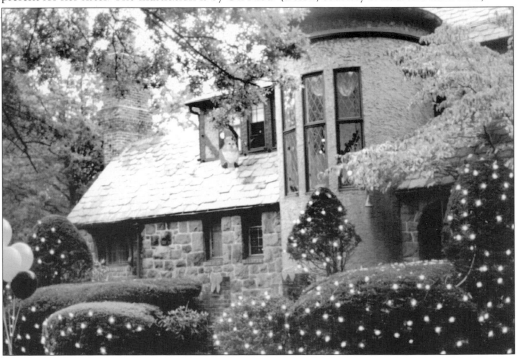

Music filled the air in Eastside Park as this Dixieland band entertained visitors during the 1995 version of the Eastside Neighborhood Association's house tour. (Courtesy of Lauren Ann Read.)

Along Eastside's East Thirty-sixth Street is this 1928 Federal Revival home with a copper covered portico. Its renovation won the owners the Heritage Citizenship Award from the Historic Preservation Society of Paterson.

Mayor John Hinchliffe was the original owner of this 1926 English Manor house at East Park Drive. The four-bedroom house, with Gothic entry, upper bay windows, and stained glass, has four bedrooms and a butler's pantry. The house has been a favorite on the Eastside Neighborhood Association's fall tour of homes. (Illustration by Gil Riou.)

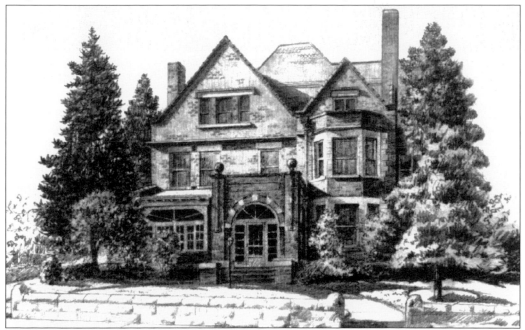

On Park Avenue, James E. Simpson chose to build his Richardsonian Romanesque home for his 13 children in 1898. The home of the silk dyer took six years to complete, with extensive use of Flemish brickwork, limestone, brownstone, and bluestone. Among its many adornments, the house features eight fireplaces. (Illustration by Gil Riou.)

This home on East Thirty-eighth Street features a pink marble floor in the foyer and an exquisite stained-glass window that illuminates the stair landing. (Courtesy of Lauren Ann Read.)

A banker and a broker, Henry Campbell chose a bold columned look for his home on Park Street, near the corner of East Thirty-sixth Street. (Courtesy of the Paterson Museum.)

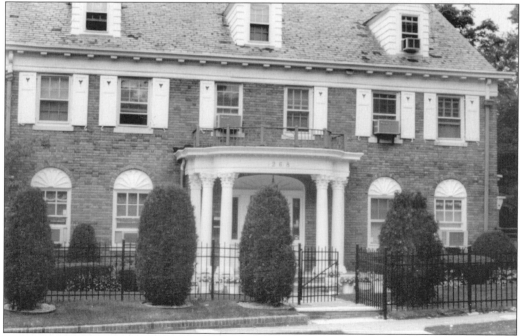

It was 1960 when the Michelson family "moved up" from East Twenty-fourth Street to this home on Derrom Avenue, said daughter Janet Michelson Read. Her father, Henry, was a physician associated with Paterson's Barnert Memorial Hospital, and her mother, known as Dusty, was a nurse.

This home on East Thirty-seventh Street is noted for its impressive entry foyer, which features a circular staircase and a copper roof with weathered verdigris patina. (Courtesy of Lauren Ann Read.)

On Derrom Avenue in Eastside lived Antonio Scola, his wife, Veneranda Pandolf, and five children. Scola, born in southern Italy in 1864, came to America in 1881 and learned the silk-dyeing trade with the Weidmann Silk Dyeing Company. Later, in the early 1900s, Scola—said to be concerned about achieving quality over quantity—would become the founder and owner of the Scola Piece Dye Works.

This photograph of the mill owner's Seventeenth Avenue home was taken c. 1936 by Lewis Hine and is courtesy of the National Archives. Eastside had roomy and stately homes, yet America's love affair with the automobile and the highways to get there opened up new frontiers by 1949. In neighboring East Paterson, homebuilder Garden State Homes was advertising three-bedroom bungalows for $9,000, an enticement to inner-city dwellers in the postwar era. For veterans, they could be had with no money down. (Courtesy of the Paterson Museum.)

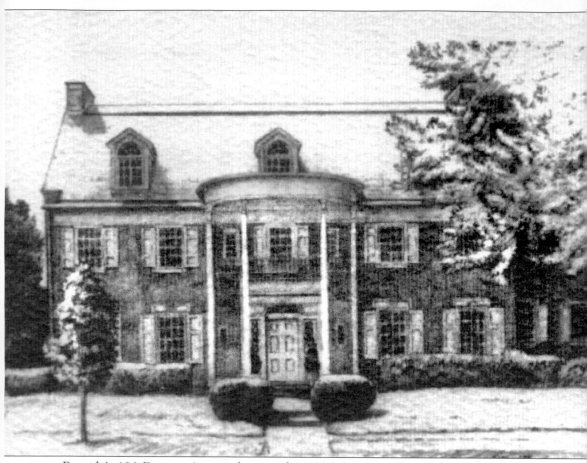

Eastside's 196 Derrom Avenue features this 1926 Georgian Revival home originally built for Charles P. Cole, owner of Standard Dye and Silk. The grand entryway features circular walls and twisting staircase. The original kitchen features a 1926 eight-burner stove. The most striking feature is believed to be the spectacular third-floor ballroom. (Illustration by Gil Riou.)

This enormous home on Derrom Avenue was once abandoned, only to be brought back to life and featured again and again on the Eastside Neighborhood Association tours.

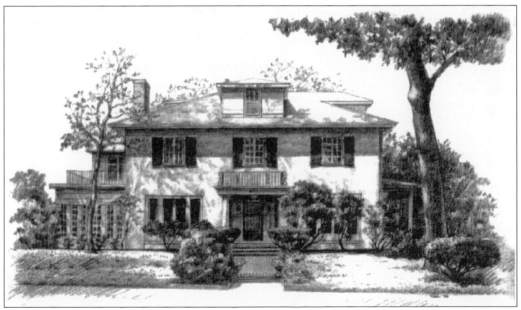

With its Gothic-style entry foyer, this c. 1920s home on East Thirty-eighth Street once had a notable guest—Pres. Gerald Ford. (Illustration by Gil Riou.)

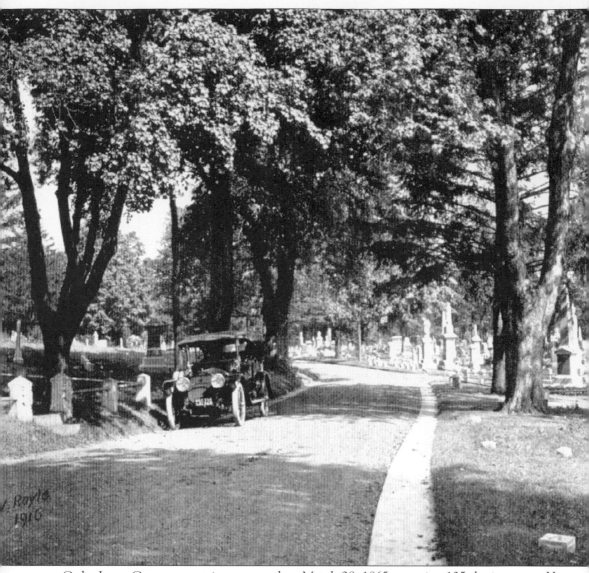

Cedar Lawn Cemetery was incorporated on March 28, 1865, covering 135 sloping acres. Here, many of the reinterments from the old Sandy Hill Cemeteries took place. From the city's oldest graveyard on Water Street came the bones of Gen. Abram Godwin of the Revolutionary War. "Here lie the Danforths, Rogers, and Cookes, who developed the locomotive industry in Paterson," reads a 1917 guide published by the cemetery. "The Barbours, whose great thread industry is now represented by a fourth generation; John Ryle, the Father of the Silk Industry, and a host of their successors as well as men eminent in other walks of life, such as Philemon Dickerson, at one time secretary of state; and Garret Hobart, who filled the office of vice president with distinction." This view, at Vernal Avenue near the Circuit, was taken in 1916 by Vernon Royle, then one of Cedar Lawn's directors.